RAINBOW CHILDREN

THE ART OF CAMILLA D'ERRICO

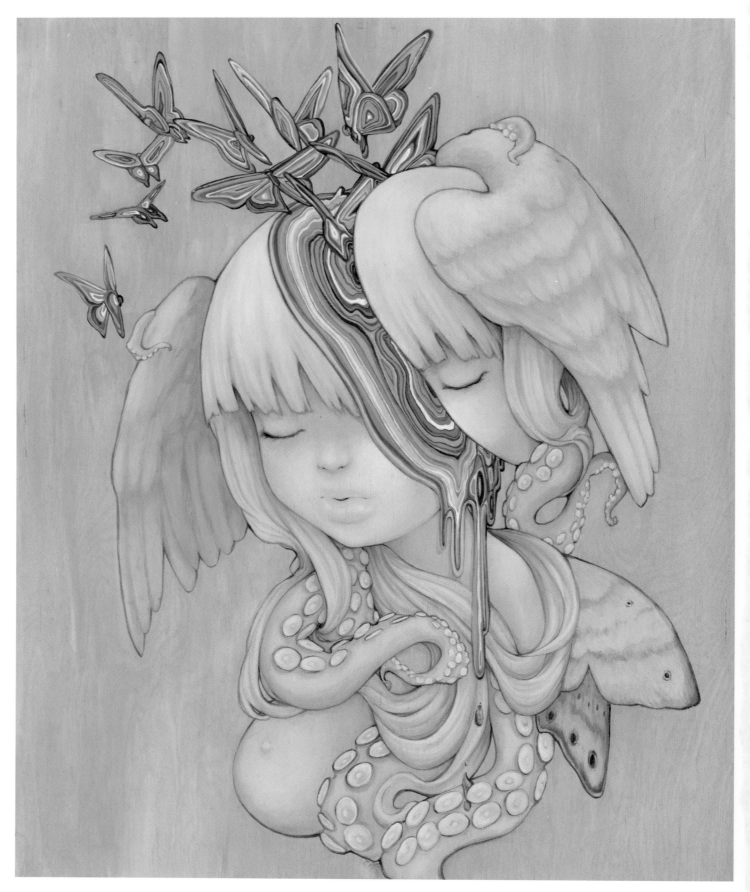

THE MELTING MIND | 16" x 20" | OIL | 2013

RAINBOW CHILDREN

THE ART OF CAMILLA D'ERRICO

Foreword by
TARA McPHERSON

DARK HORSE BOOKS

DEDICATION

*I'd like to dedicate this book to all the colorful
people I know that make up the rainbow of my life.
This one's for you, my fellow weirdoes.*

SPECIAL THANKS

*Thank you, Life, for always throwing me
the curve ball I didn't know I needed.*

10 9 8 7 6 5 4 3 2 1

President & Publisher MIKE RICHARDSON | Editor AARON WALKER | Assistant Editors RACHEL ROBERTS & ROXY POLK
Designer KAT LARSON | Digital Art Technician CHRIS HORN

Dark Horse Books, 10956 SE Main Street, Milwaukie, OR 97222 | DarkHorse.com | CamilladErrico.com|First edition: February 2016
ISBN 978-1-61655-833-8 | Dark Horse International Licensing: (503) 905-2377 | RAINBOW CHILDREN: THE ART OF CAMILLA

TABLE OF CONTENTS

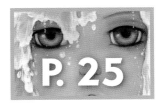
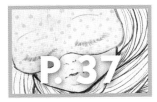
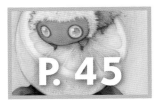
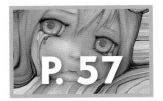
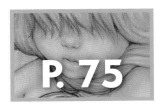
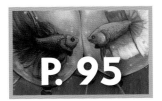
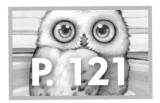
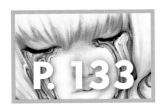
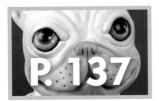
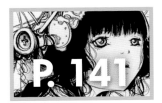
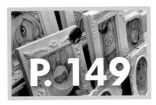
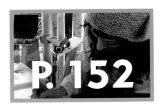

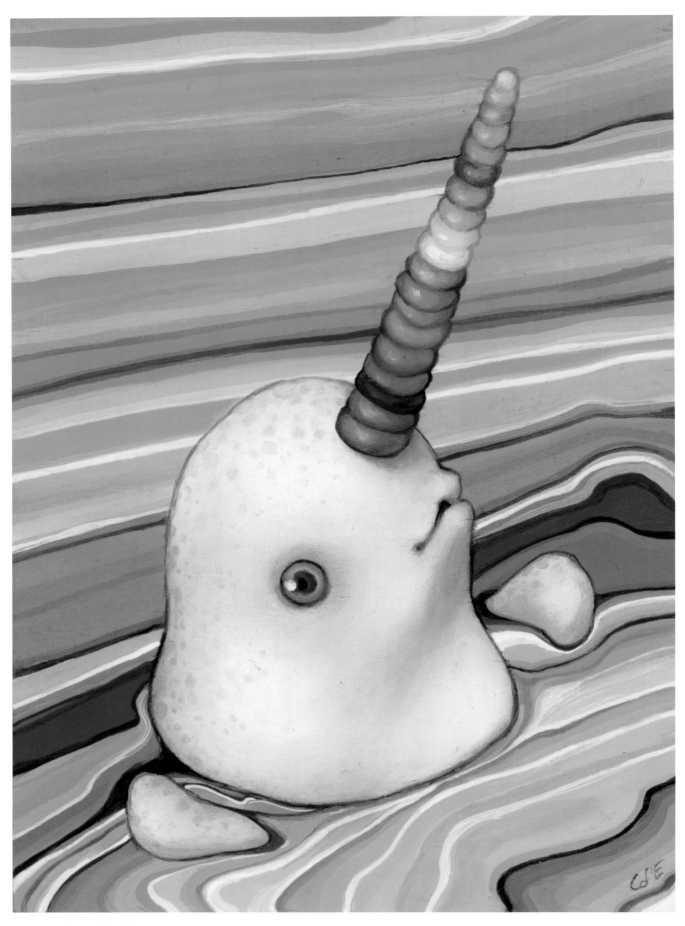

NARLENE | 5" x 7" | OIL | 2015

FOREWORD

I LOVE STARING AT ART . . . Looking at the details, studying the line work, figuring out painting techniques: these are just some of the things that entrance me in Camilla d'Errico's artwork. I love that she creates such gestural flows with her lines; you can just feel the movement and weight of her characters. There is a lovely balance of freedom and refinement in her technique, and it's this intersection that helps create her beautifully painted dream world.

Taking inspiration from great Japanese artists like Katsuya Terada and Hayao Miyazaki, pop culture, and the beautiful creatures nature has created on this planet, and adding her own distinctly feminine touch, she has created portraits of *kawaii* girls and sweet animals playing in a blissful world of cuddle piles. Maybe they would not be friends in the real world, but that doesn't matter here; these girls get to do what most of us would want to do, and they cuddle hard. As an artist's path is an ever-evolving journey, I can see her new work exploring a more introspective place, sometimes delving into an abstracted world of color and emotion. I had the pleasure of showing Camilla's work at my art boutique, Cotton Candy Machine, here in NYC, and she said her shows with us allowed her artistic growth the freedom to flourish. It is a wonderful evolution; I am especially grateful to have seen it happen in person.

The transition from drawing comics to painting is not an easy one, and that's where some artists fall short. Camilla is not one of them; she shines when she paints. Her unrestricted brushstrokes and soft blending of colors, combined with well-placed accents in shadows and highlights, make for beautiful painting techniques. Her work is soft, alluring, dreamlike, and hazy, like when you wake up and your dream is softly fading away, and you are left with a sweet vision that might look like one of her paintings.

—TARA McPHERSON

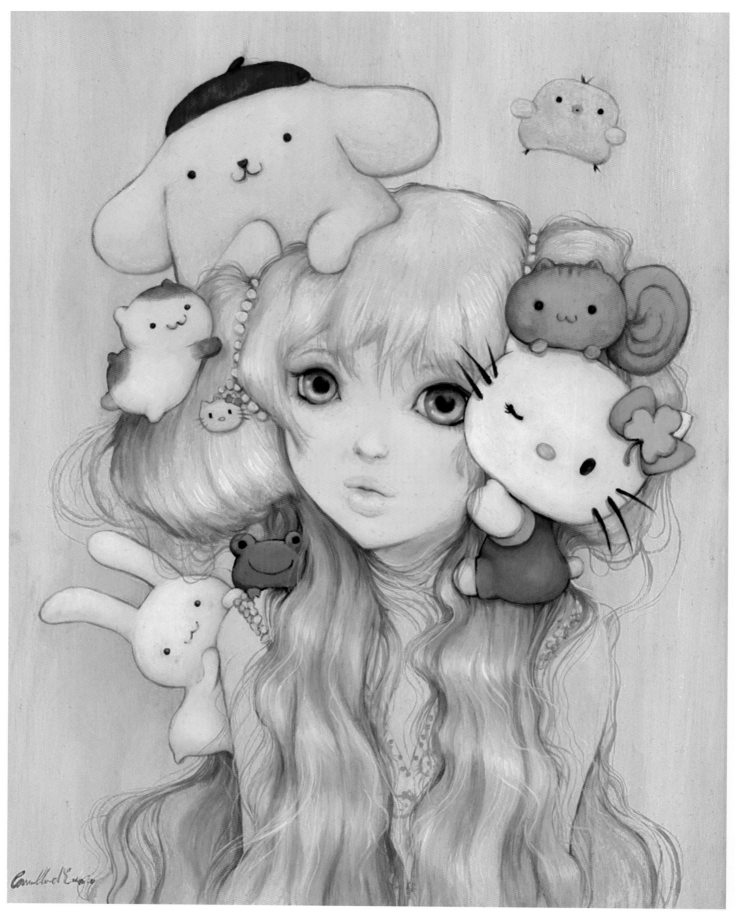

POM POM KITTY PIE | 16" x 20" | OIL | 2009

INTRODUCTION

MY ARTISTIC PLUNGE DOWN THE RABBIT HOLE began one fateful Saturday morning many years ago, when my mother sat me down in front of the TV. *My Little Pony*, *Rainbow Brite*, and Strawberry Shortcake, with her motley crew of colorful tots, mesmerized me and transported me into a cartoon land—and I have, in fact, never left that world. I'm immersed in pop culture, and throughout childhood, adolescence, and adulthood, I've stayed young at heart because of it.

I surround myself with all varieties of art, from Renaissance masters like Raphael, to the sea of manga and anime produced in the Far East, to present-day artists in the pop surrealist movement in North America and Europe. Art is my life, and I made it that way on purpose!

This book is another step into my artistic journey. It will focus on my gallery exhibits between 2012 and 2015. It is a departure from my previous books and artwork because it's broken down by exhibitions rather than themes. Before 2012 I was focused mostly on a classic portrait style, and this collection is far from that. It was like I was bouncing on a trampoline for years, and one day I jumped really high and accidentally ended up in another world.

In 2011 I took a hiatus from gallery work. I was burned out, and I wanted to take a deep breath creatively and refuel myself. My creative side needed a spa day, which turned into about one year. Creativity isn't an infinite well, and sometimes it's necessary to pause and let those creative waters replenish. I'm very glad I did, because the artwork I've created since my hiatus has been some of my most imaginative work.

Artists go through journeys with their work, and I am no exception. This journey was like a winding, twisting, sometimes catapulting experience into discovering my inventiveness. I pulled images and pictures from other worlds and dimensions that twisted reality and existed without regard to logic or reason or sometimes even physics. Rainbows became physical objects that I could manipulate; animals came to life as the stars of my work, rather than as adornments for my big-eyed girls. My femmes fatales evolved into half-human, half-animal dreams, and colors brightened and faded like a setting sun.

I hope when you fall into the rabbit hole that is my pop surrealist world, you will come out the other side a changed person.

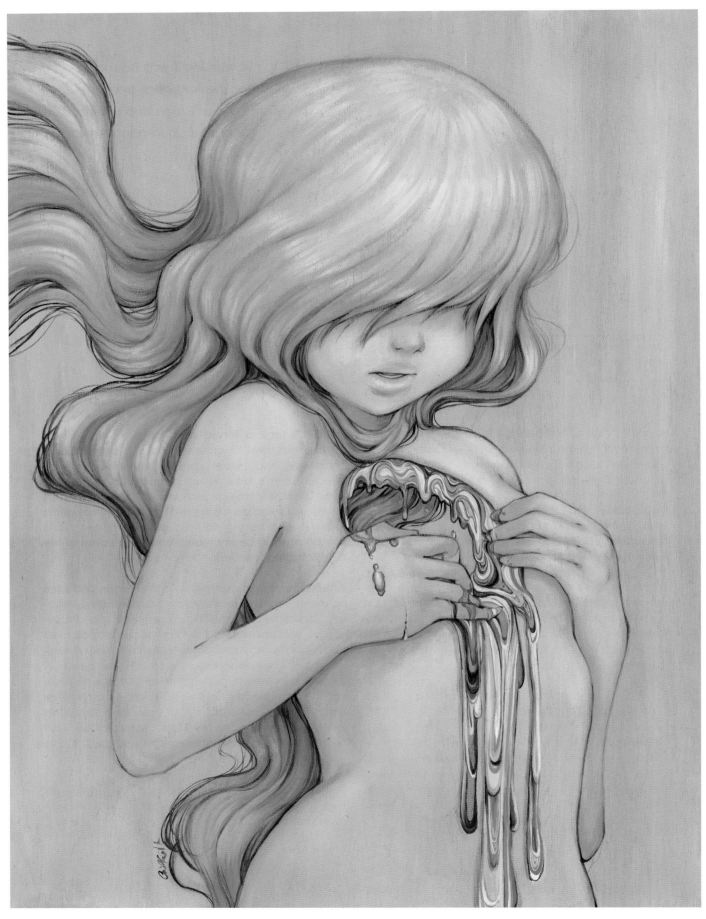

BEYOND THE RAINBOW | 12" x 16" | OIL | 2012

THE CANDY ESCAPE

THIS SERIES OF PAINTINGS WAS PART OF *THE CANDY ESCAPE*, a two-person show with Brandi Milne at Cotton Candy Machine in Brooklyn. The gallery is owned and operated by Tara McPherson, in my opinion one of the greatest pop surrealist artists in the art scene right now.

When Tara asked me to participate in the show, it was during a small hiatus I had taken from painting. This came at a time when I wasn't sure whether or not I wanted to continue to be a gallery artist. I was in a creative rut, to put it simply. But after a conversation with Tara, everything changed. She was so sweet and encouraging. There was no pressure whatsoever from her or the gallery to produce a certain amount of pieces or create a specific theme; she told me I was free to paint whatever I wanted.

It was a simple suggestion, and often those are the ones that can have the most influence. It impacted me like an asteroid slamming into the earth's surface. It was a game changer for me.

The collection of pieces in this series was a complete and total departure from any I had previously done. I had been known for my images of big-eyed girls with animals, presented in a portrait style. So trust me when I tell you that creating these new pieces was a staggering departure from what I'd previously done. Hiding the characters' features and making them floating half-human, half-melting girls was a risk that I was finally willing to take.

The first piece I created in the series was *Beyond the Rainbow*; the girl in the picture was in essence me at the time. I felt like I had a hole in my chest where my heart was supposed to be, because my heart wasn't in the art (see what I did there?) and I felt like all my creativity was pouring out of me.

"Oh, universe, you're such an ironic, sassy mama." As soon as I vocalized my feelings, an image of a girl with a hole in her chest bleeding rainbows flew into my brain. From that point on, my entire perspective shifted. I felt liberated and free to be creative.

That freedom, of course, came at the possible price of losing some of the older fans that loved my art the way it was—showing girls and animals in harmonious and emotional scenes. I was facing the possibility that I might upset my fan base, but I couldn't hold back; I had to go for it. I'm glad I did. My fans seemed to embrace my new direction. I'm forever grateful to them for giving me the space to try something new.

So when you look through this chapter, you might notice how playful and emotive the pieces turned out when I went to a place I hadn't gone before. To quote my favorite captain: "To explore strange new worlds, to seek out new life and new civilizations, to boldly go where no one has gone before!"

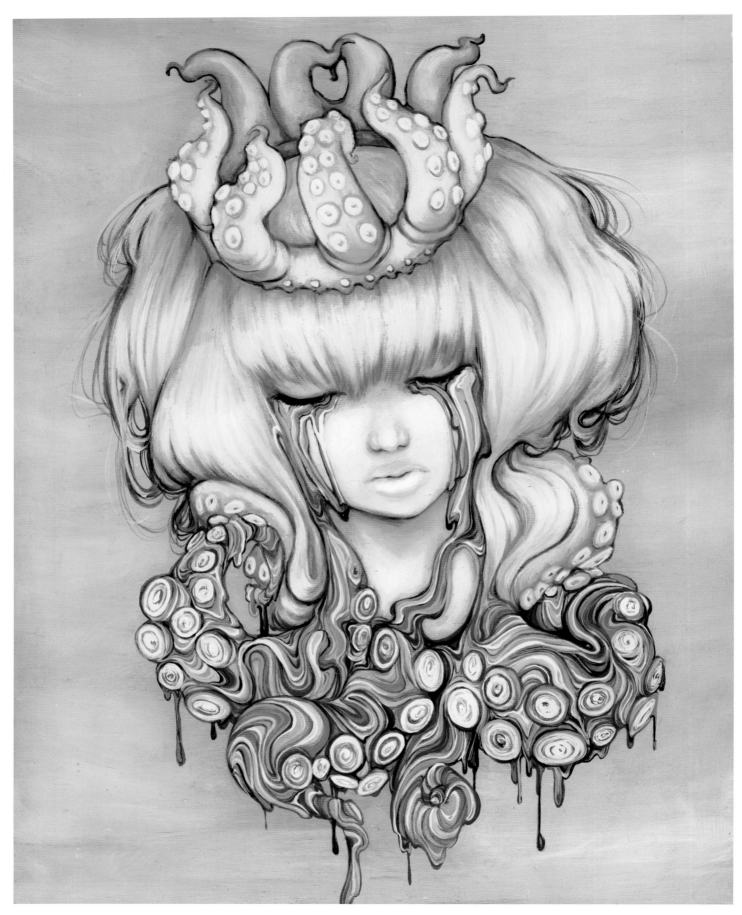

DREAM MELT | 11"×14" | OIL | 2012

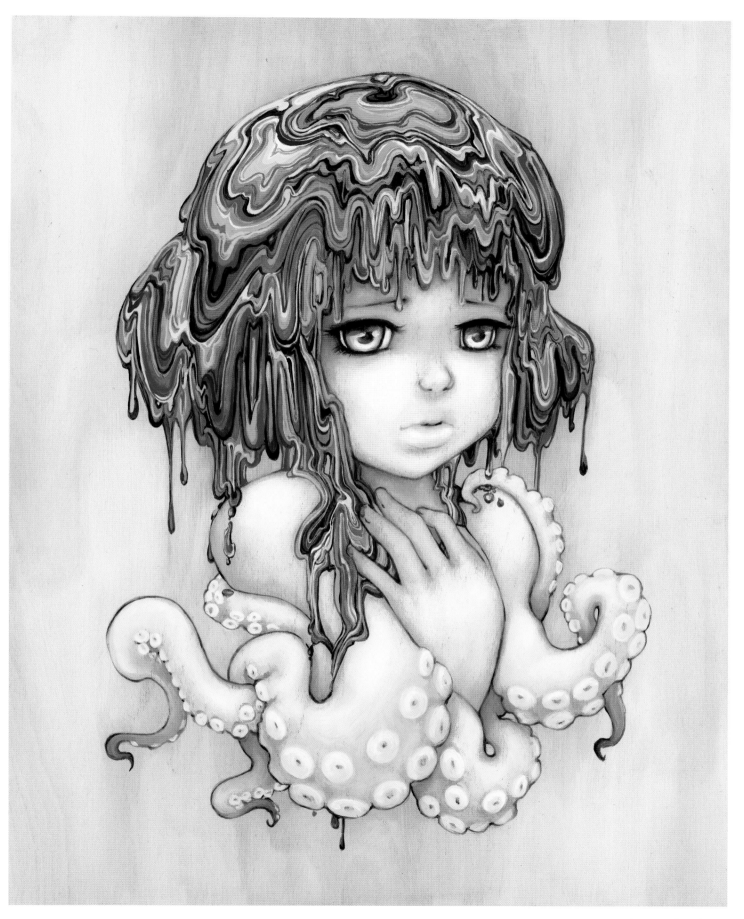

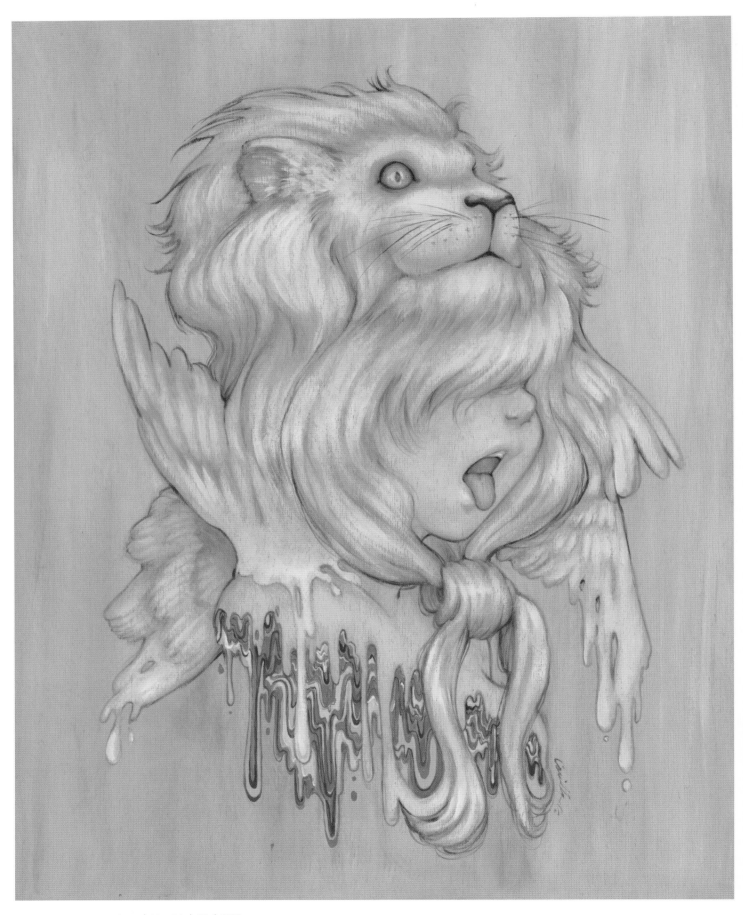

HEAR DANIELLE ROAR | 11" x 14" | OIL | 2012

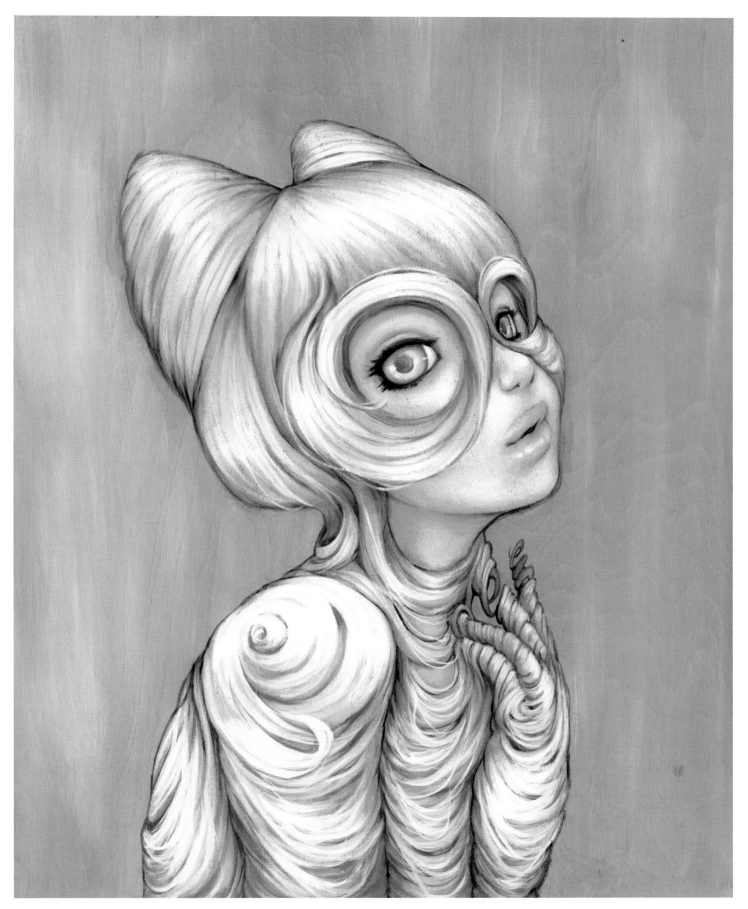

HAIRBALL | 11" x 14" | OIL | 2012

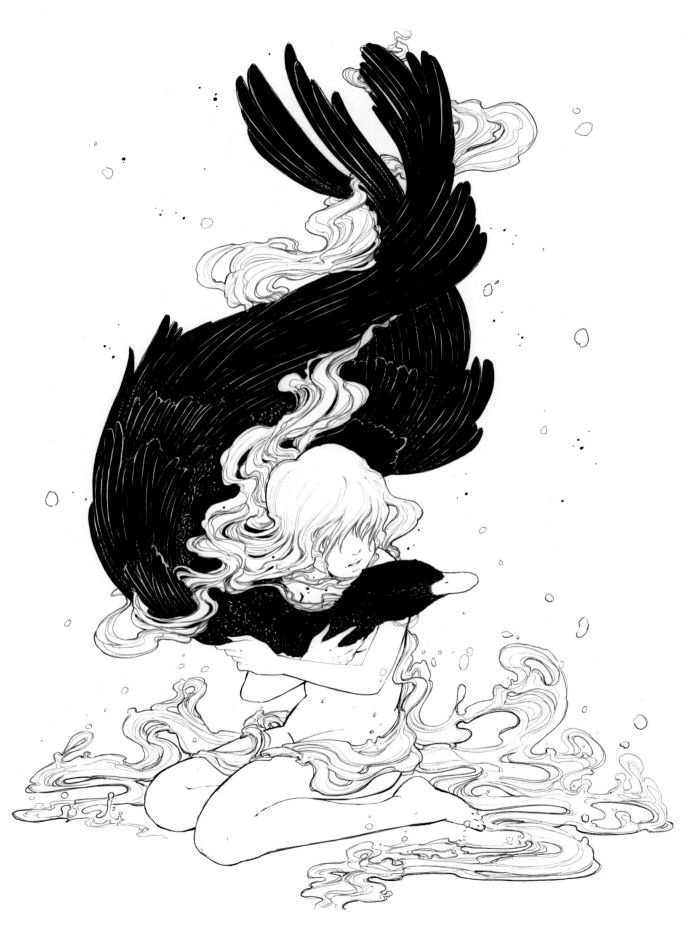

SUPERFICIAL SUBSTANCES | 11" x 14" | INK | 2012

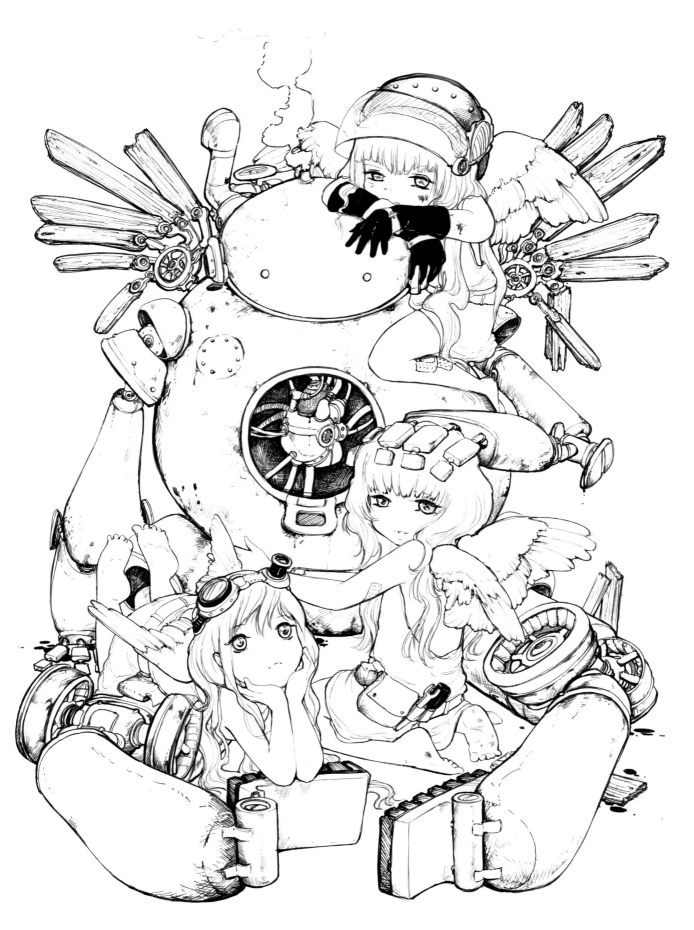

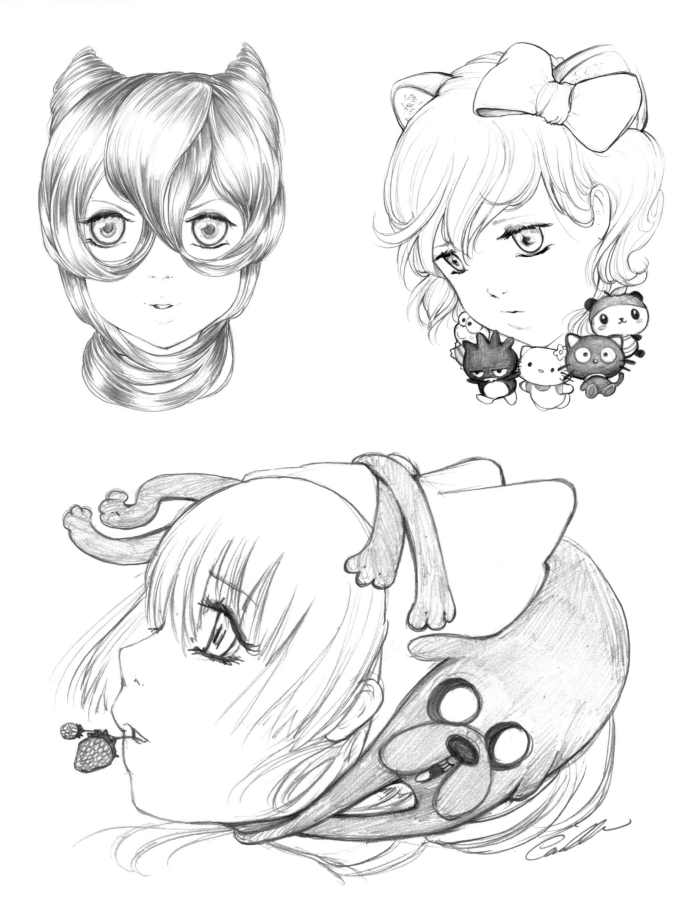

MEOW | 5" x 7" | GRAPHITE | 2012
KITTY CANDIES | 5" x 7" | GRAPHITE | 2012
ADVENTURE-BERRY | 6" x 4" | GRAPHITE | 2012

18

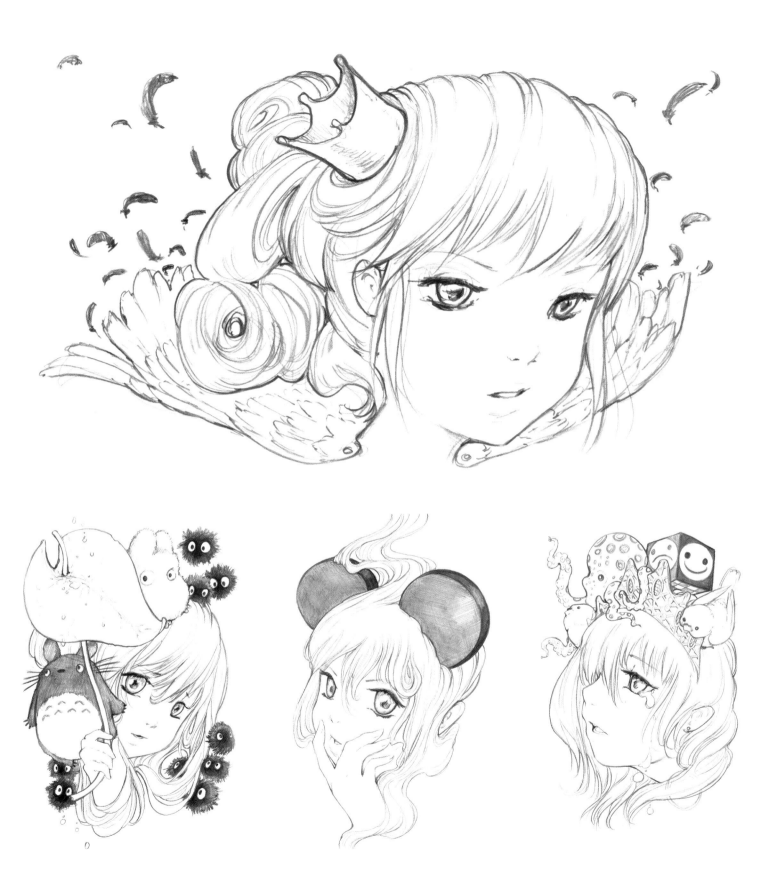

SWAN PRINCESS | 6" x 4" | GRAPHITE | 2012
DUSTY BUNNIES | 5" x 7" | GRAPHITE | 2012
WHO'S THE MOUSE NOW? | 5" x 7" | GRAPHITE | 2012
LETTING THEM GO | 5" x 7" | GRAPHITE | 2012

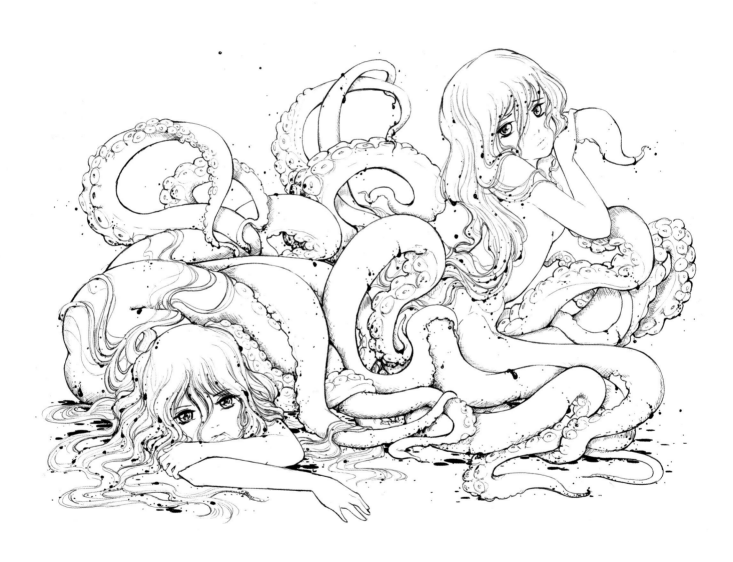

TANGLED TENTACLE SPILL | 14" x 11" | INK | 2012

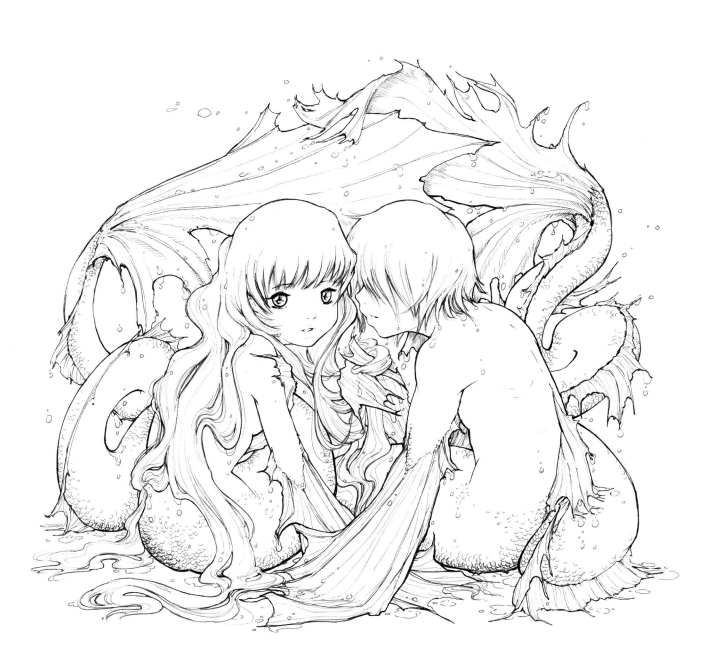

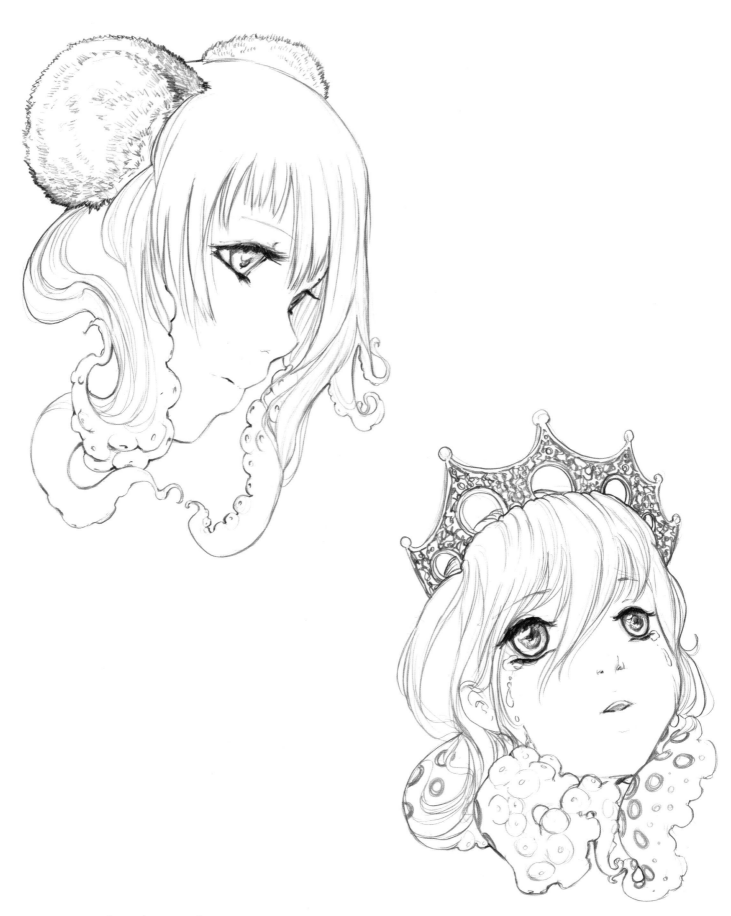

SURF AND TURF | 5" x 7" | GRAPHITE | 2012
TASTY TENTACLE TEARS | 5" x 7" | GRAPHITE | 2012

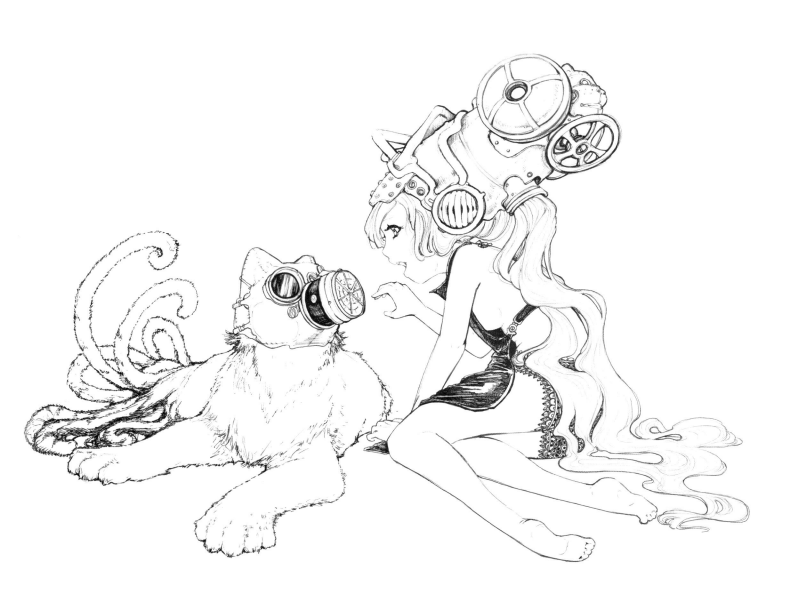

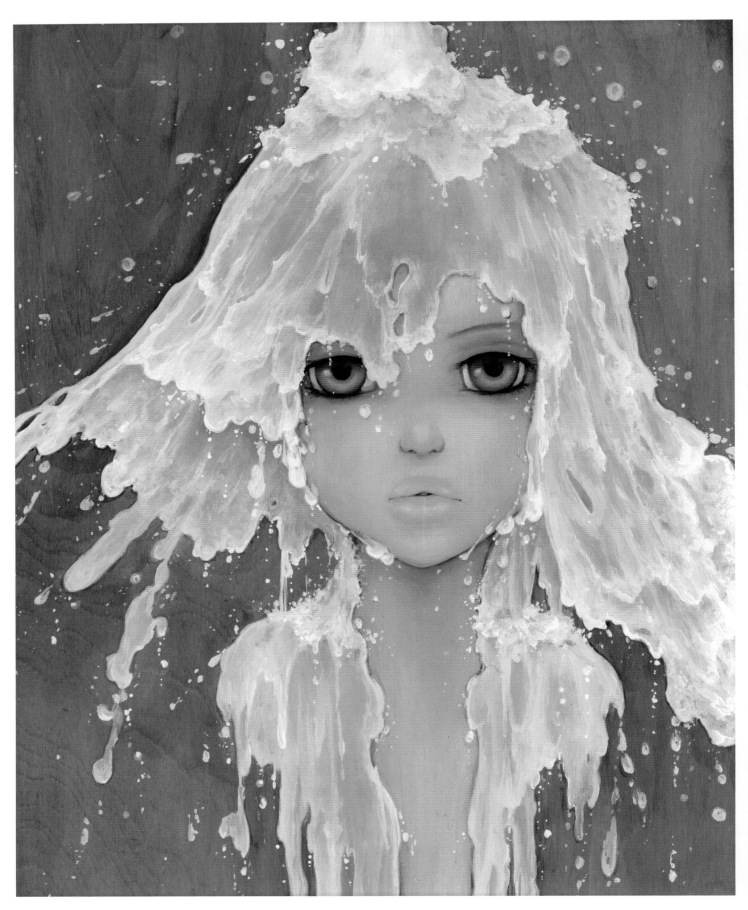

MILKFALL | 11" x 14" | OIL | 2013

SPILLED MILK

THERE WAS A CERTAIN AMOUNT OF COMFORT in knowing that the follow-up exhibit to the *Candy Escape* show ended up being at the Ayden Gallery in my hometown of Vancouver, BC. So I was able to lean on the support of my friends, family, and the wonderful local fans.

This show was unique in that it had no theme whatsoever, and that was a first for me! Before this exhibit, I'd always created paintings that existed within a similar plane of existence, as if they came from the same galaxy. But not the *Spilled Milk* girls; they were unique creatures that came from an entire universe and converged in one space.

For me it was all about breaking the rules this time. I think the most daring of all my pieces from this show was *The Beekeeper*. This was the first time I'd ever altered the eyes of a character. Rather than paint big, beautiful, colorful eyes, I replaced them with honeycombs. My husband was the key to my going for it; he encouraged me to break the rules, so I did—and loved how it turned out!

The *Spilled Milk* show gave me the opportunity to break the boundaries of the female form. I started painting my girls without bodies, had them emerging from puddles of melting color, and even created a girl that seemed to form from a waterfall of milk.

This show was as varied and unique as my mind had ever dared to go, and it was totally liberating!

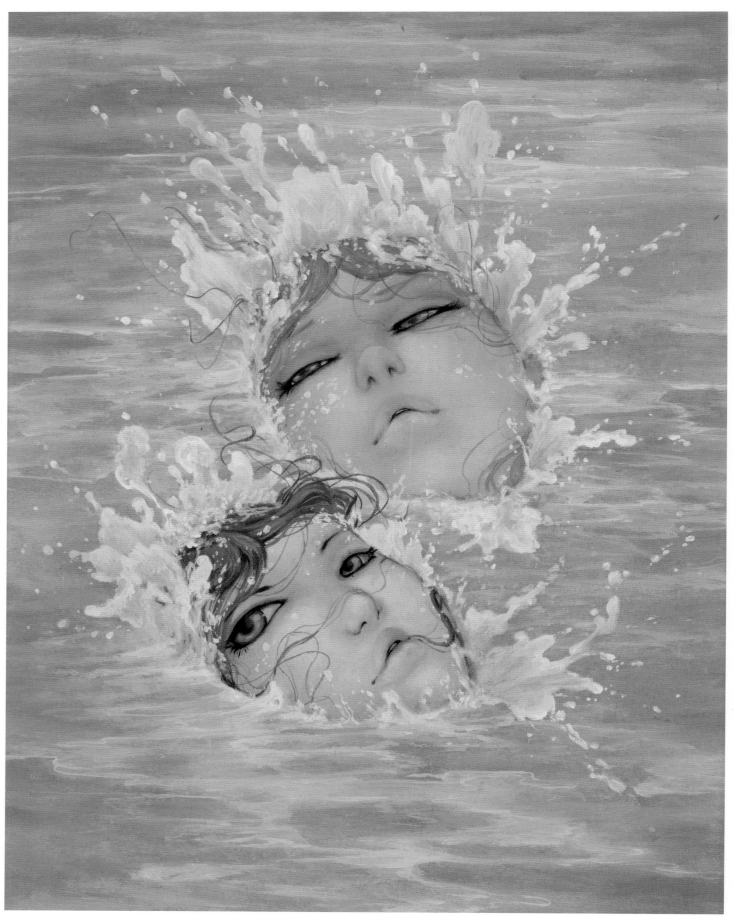

MY MILKSHAKE | 11" x 14" | OIL | 2013

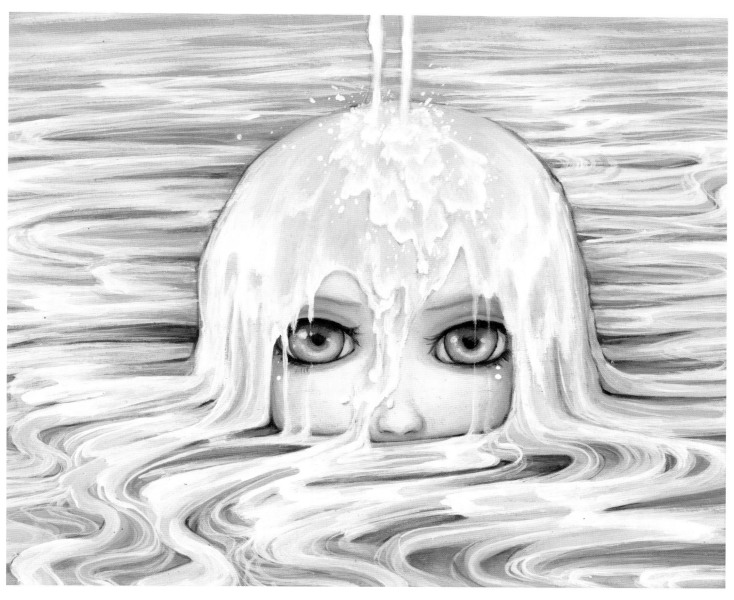

CREMA | 10" x 8" | OIL | 2013

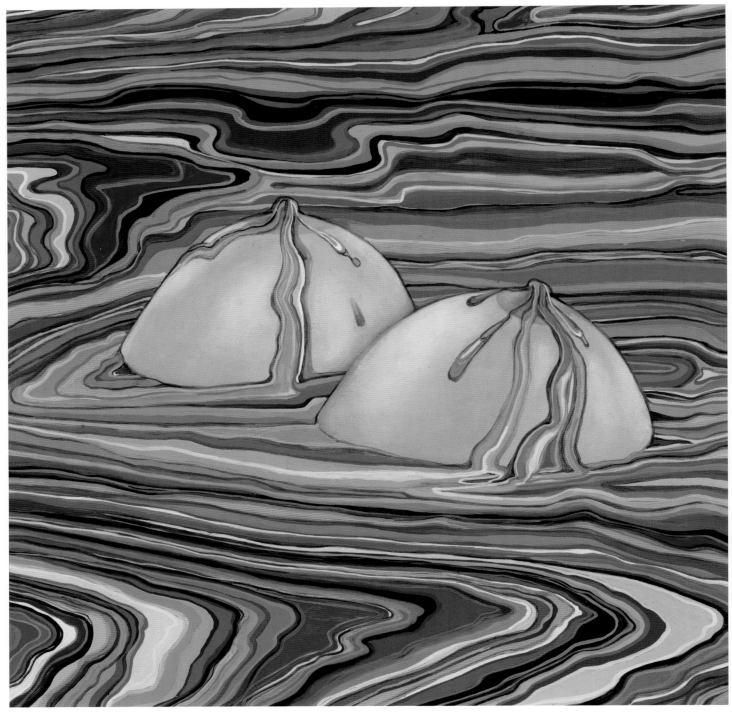

NIPS | 12" x 12" | OIL | 2013

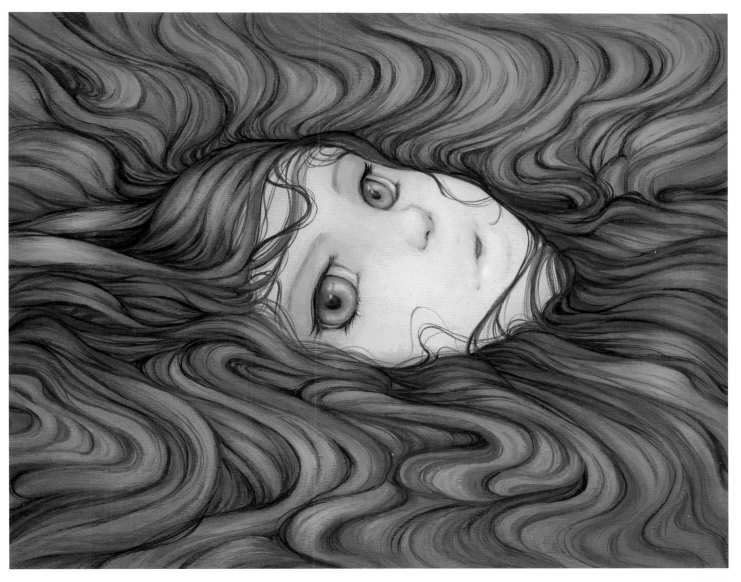

NOBLE KISS MONSTER | 10" x 8" | OIL | 2013

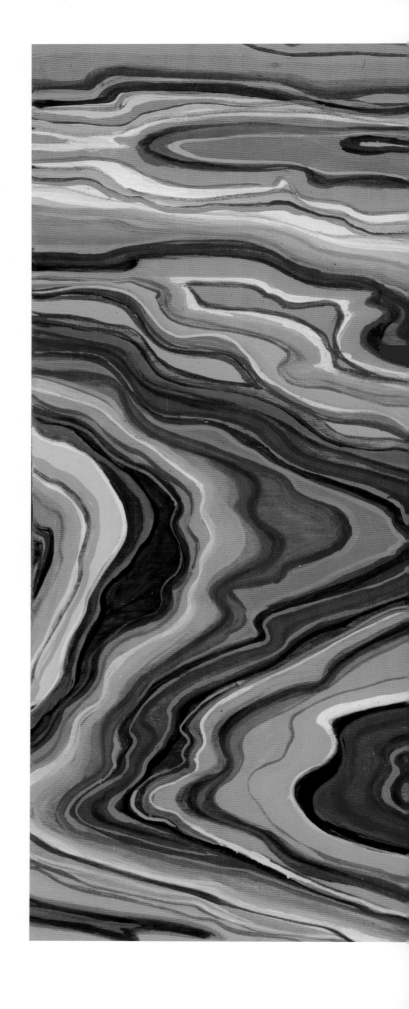

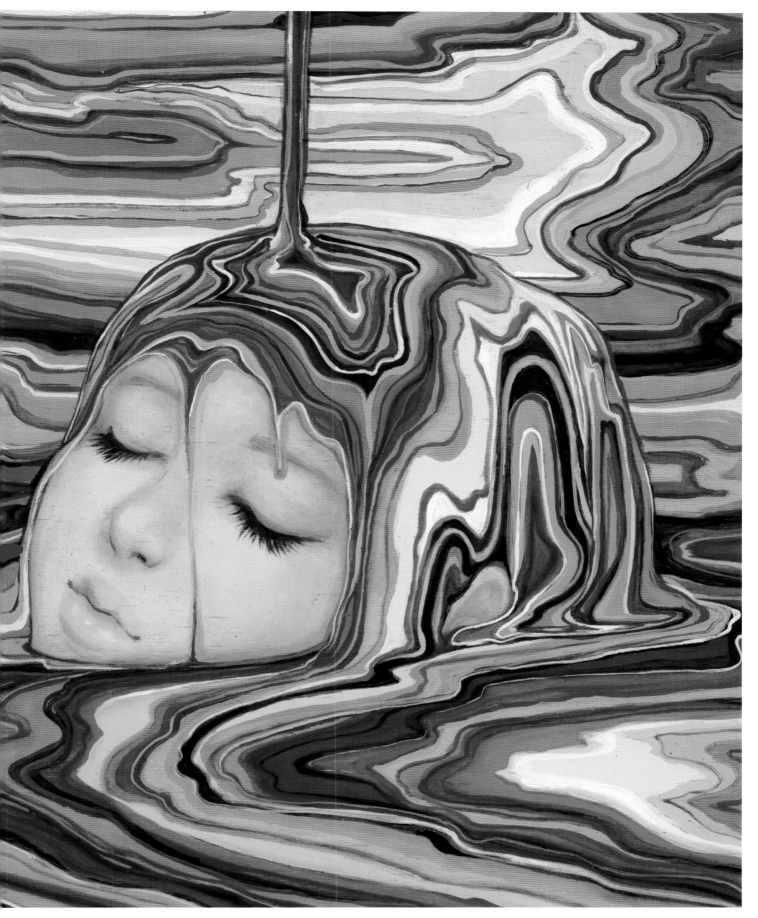

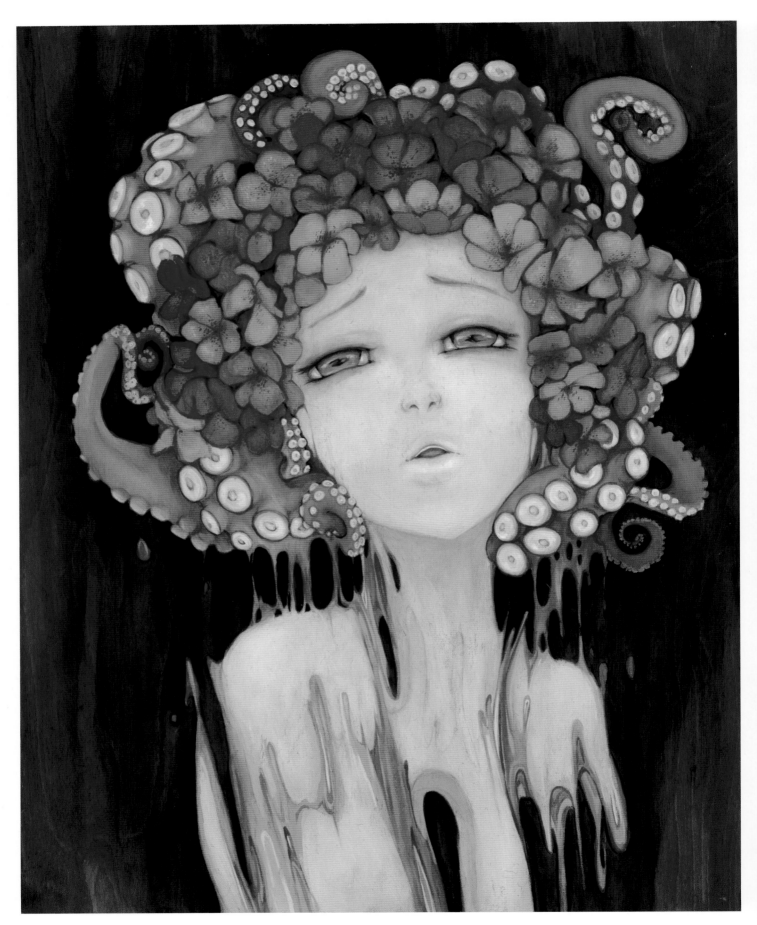

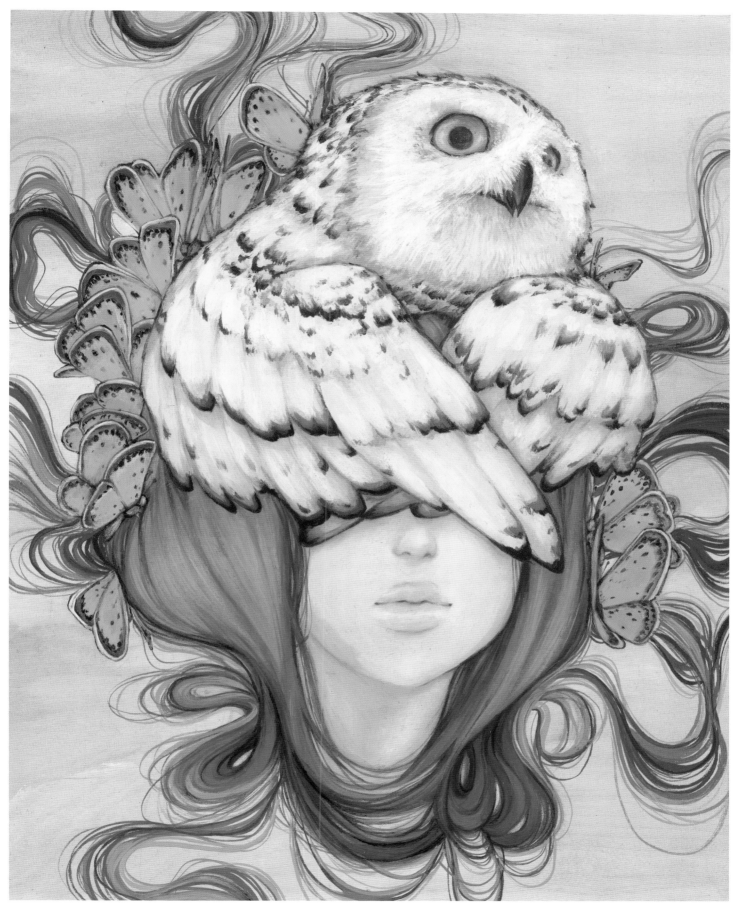

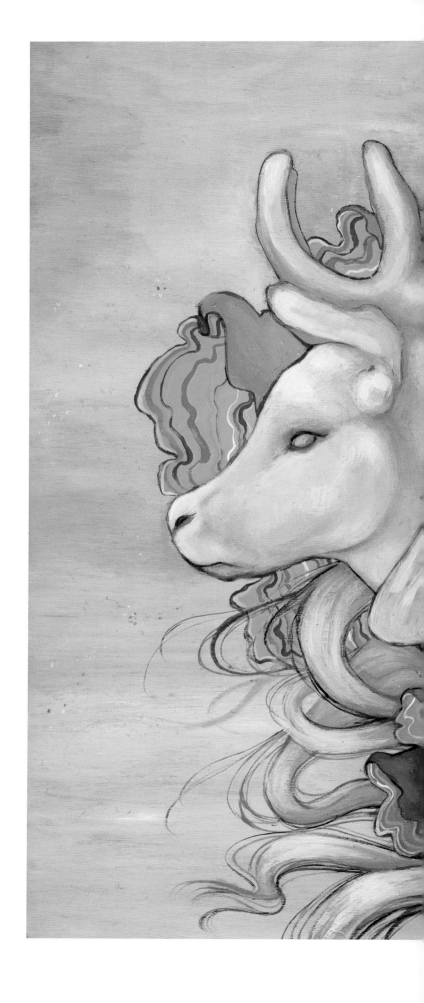

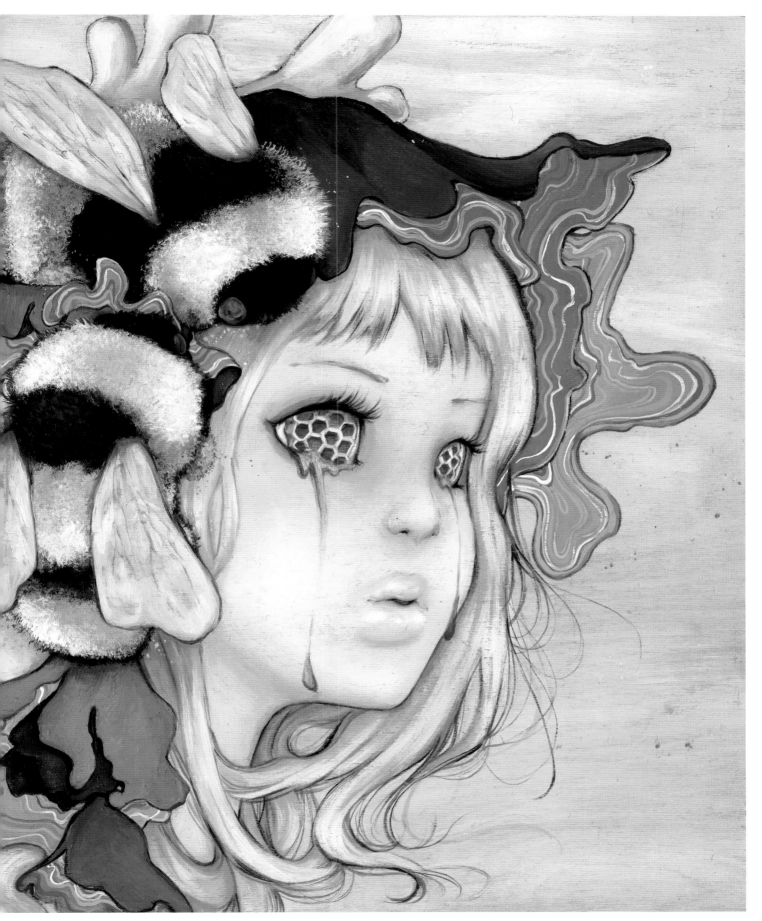

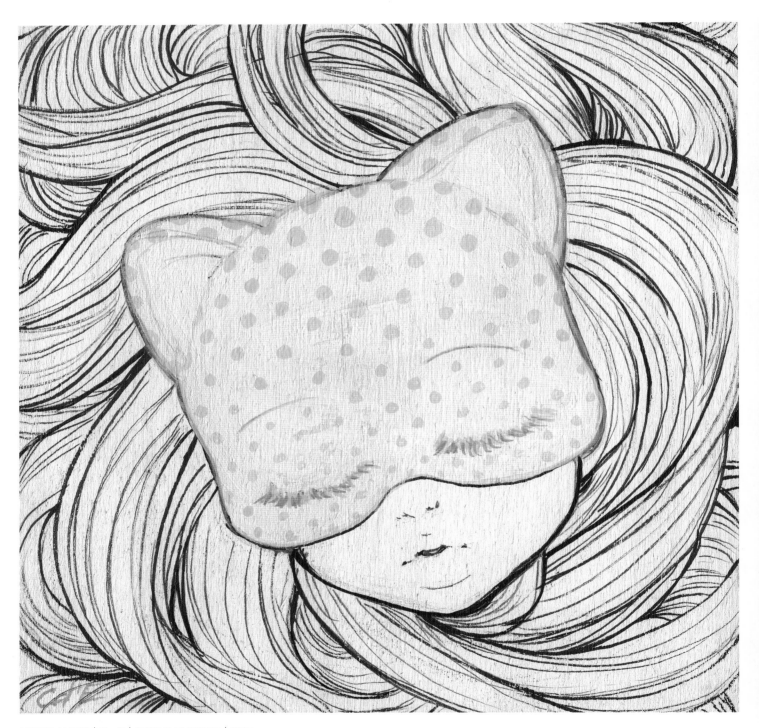

MEOW MINX | 6" x 6" | ACRYLIC ON WOOD | 2015

"It was a lot of fun to go back to my roots and use pencils. That actually opened the floodgates for the graphite drawings that I now create for all my conventions."

TINY TRIFECTA

TARA McPHERSON IS A VERITABLE PIONEER IN THE ART WORLD. Her shop Cotton Candy Machine hosts *Tiny Trifecta*, an annual art show in New York that is unlike any other. All the artwork is priced equally, no matter *who* painted it or *what* they chose to create. Each piece is $100. It's a steal! If you ever have the chance to go to the show, do it—and prepare to be amazed! The walls are jammed from floor to ceiling with tiny, incredible creations.

Whenever I do a piece for this show, I try something different. The first time I did framed graphite drawings, a style I hadn't done in years. It was a lot of fun to go back to my roots and use pencils. That actually opened the floodgates for the graphite drawings that I now create for all my conventions. Thank you, *Tiny Trifecta*, for the inspirational kick in the rear!

I've since begun to try new techniques to make each installment of my pieces in the show unique and funky. So who knows—maybe in ten years my art will be floating ink on resin!

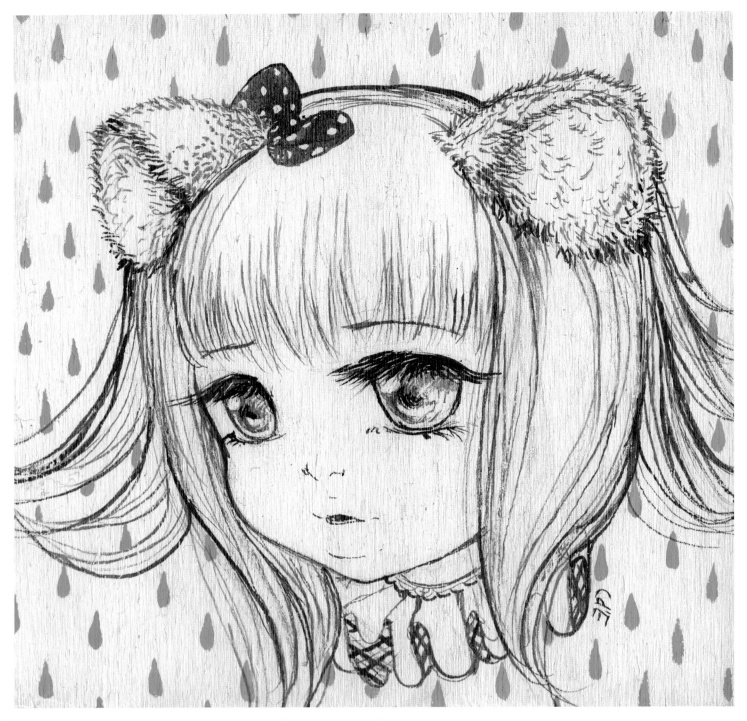

RAINDROPS KEEP FALLING ON MY HEAD | 6" x 6" | ACRYLIC ON WOOD | 2015

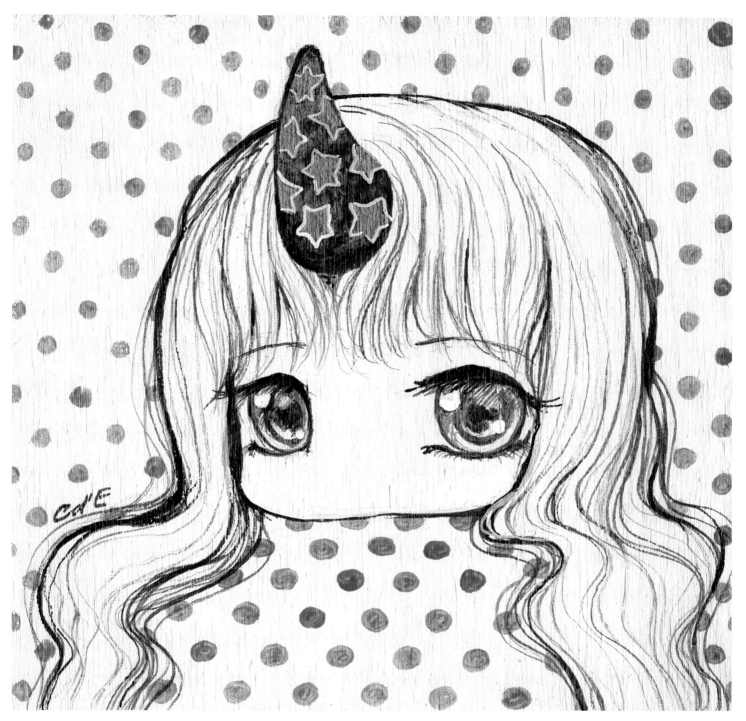

THE SUBMARINER | 6" x 6" | ACRYLIC ON WOOD | 2015

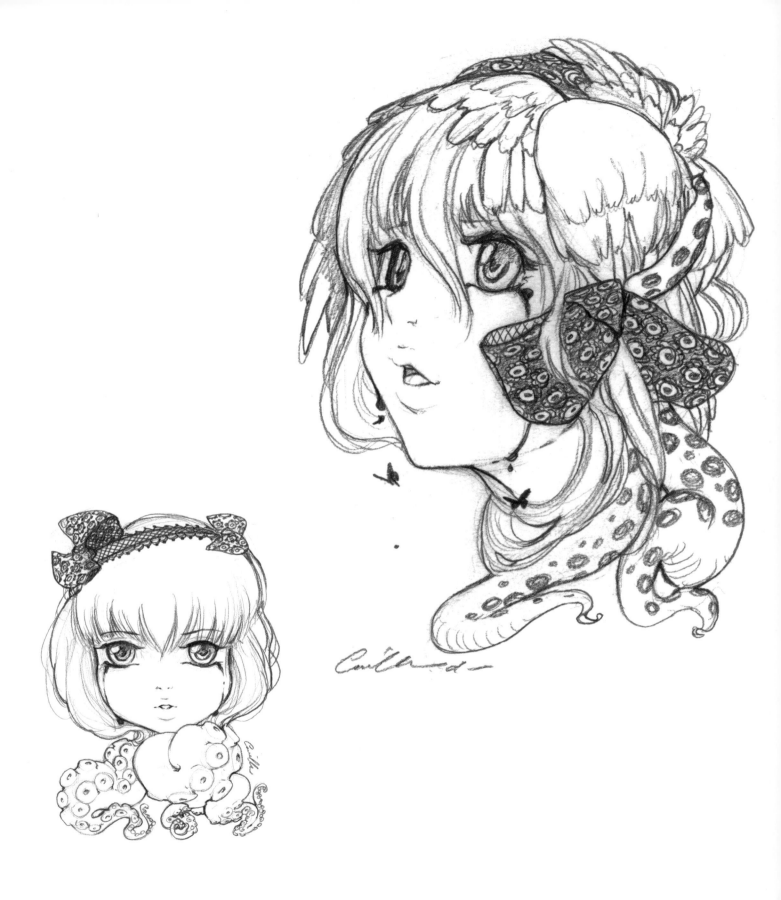

BUTTERFLY BETTY | 5" x 7" | GRAPHITE | 2013
CANDY CURL | 5" x 7" | GRAPHITE | 2013

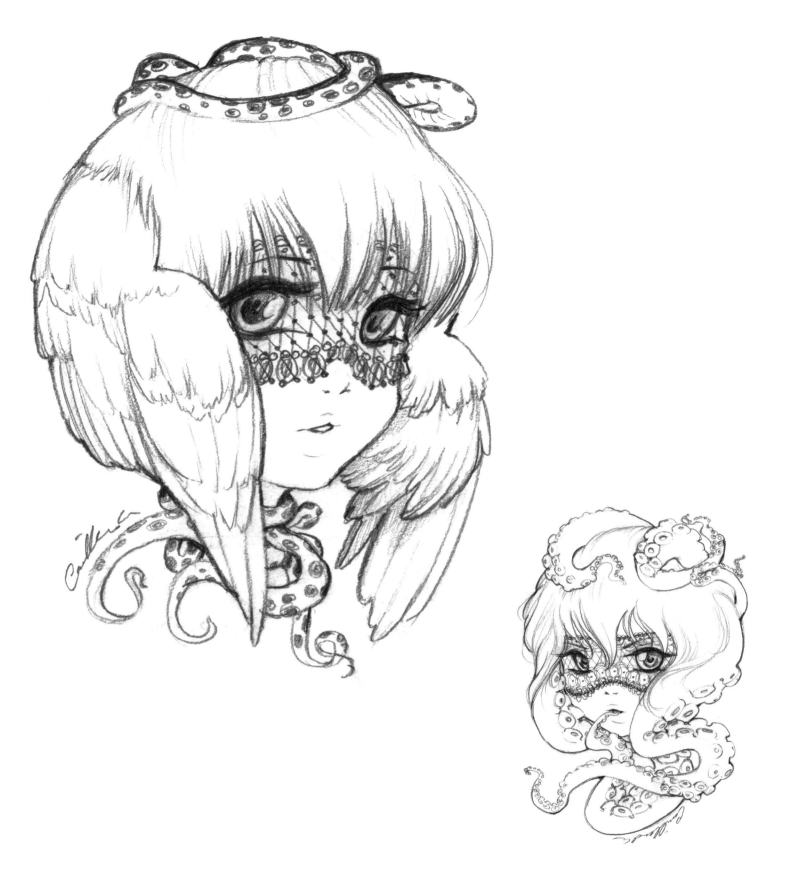

SERPENTINA | 5" x 7" | GRAPHITE | 2013
SQUIDLY SUE | 5" x 7" | GRAPHITE | 2013

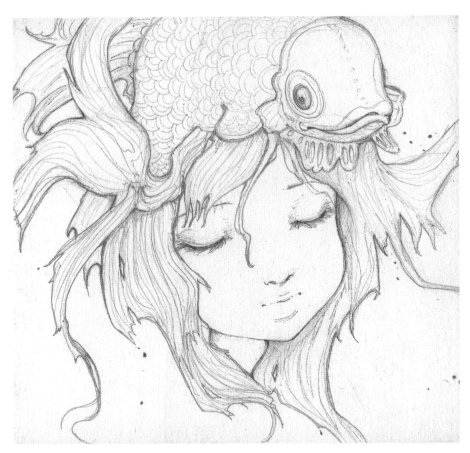

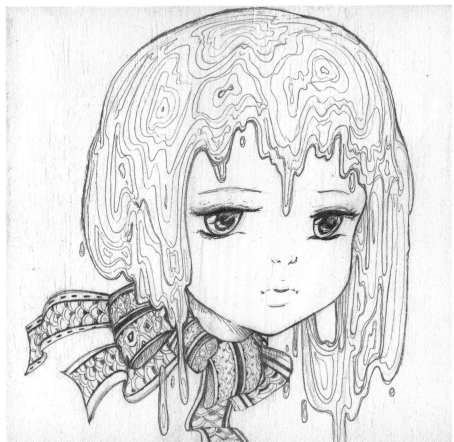

PIECIES PIE | 6" x 6" | INK ON WOOD | 2014
GELATO-CHAN | 6" x 6" | INK ON WOOD | 2014

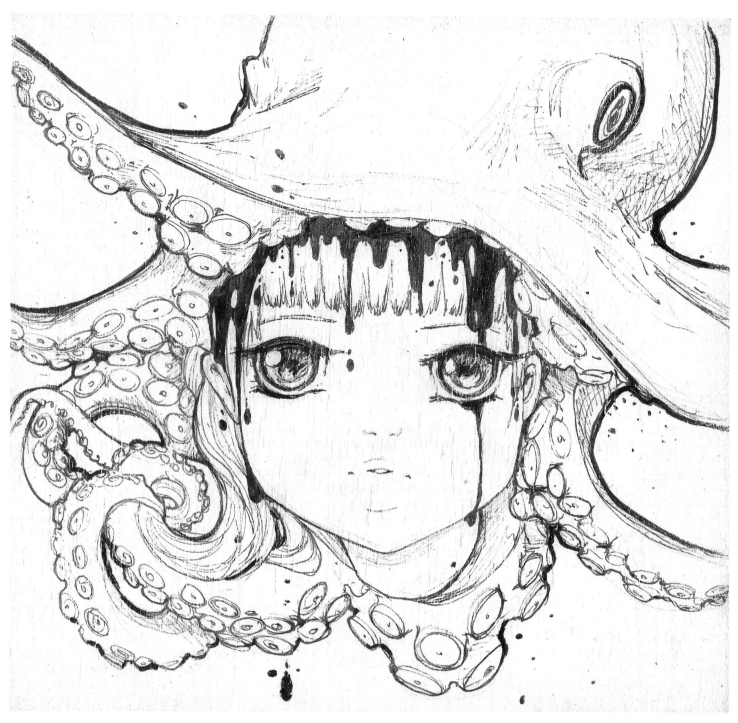

TAKO TART | 6" x 6" | INK ON WOOD | 2012

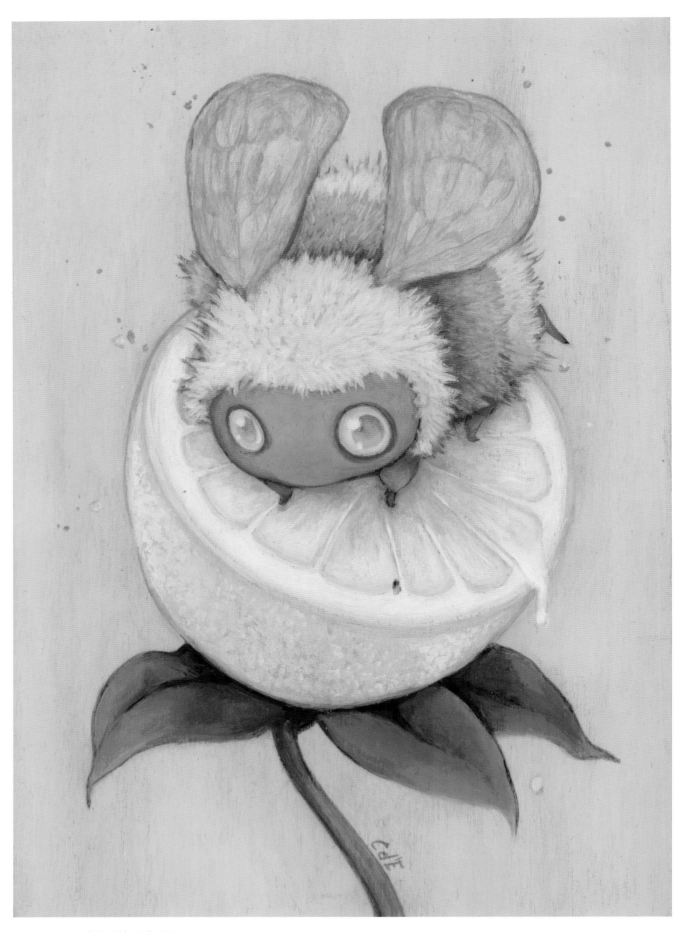

"Painting a fuzzy, cartoonish bee or watermelon-butterfly wasn't something anyone had seen me do before."

SWEETS & TREATS

THE SERIES *SWEETS & TREATS* WAS BORN FROM A COMBINATION OF LATE NIGHTS, summer treats, and a lot of sugar! Over the years I'd been painting, I'd never painted on any canvas that was smaller than 8 x 10 inches, but for this series I wanted to challenge myself to work as small as I could.

Borrowing from the brilliant *Tiny Trifecta* shows, I wanted to create a smaller series of paintings that would be more affordable for folks who were just beginning to collect my artwork. Not everyone can afford a 16 x 20 or larger piece, so I wanted to be mindful of the people who support me and help them transition from owning prints to owning originals.

The fun part was going absolutely wild with the themes. I'd always painted girls; never had I just skipped the girl entirely and gone straight for the critter . . . until this series.

It was another painting series that challenged how comfortable I was with pushing boundaries (which is becoming a theme in itself now). Painting a fuzzy, cartoonish bee or watermelon-butterfly wasn't something anyone had seen me do before. I never doubted that my fans would support me, but their response to this series was quite astounding. It made me realize that I wanted to do this more often. So this would become the beginning of a very beautiful and bizarre relationship with fruit and animals.

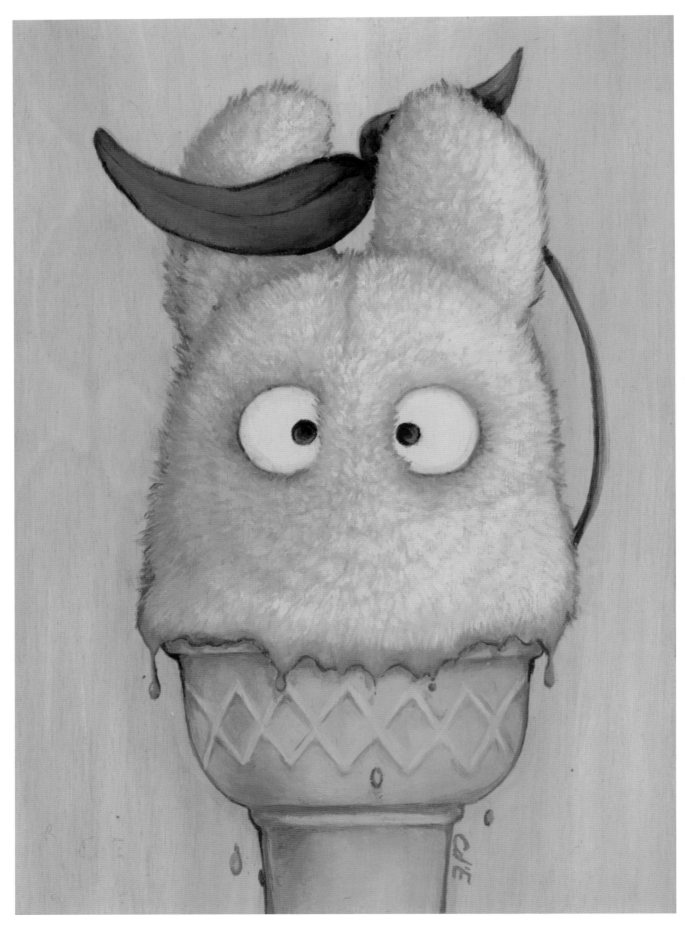

GELATOTORO | 5" x 7" | OIL | 2014

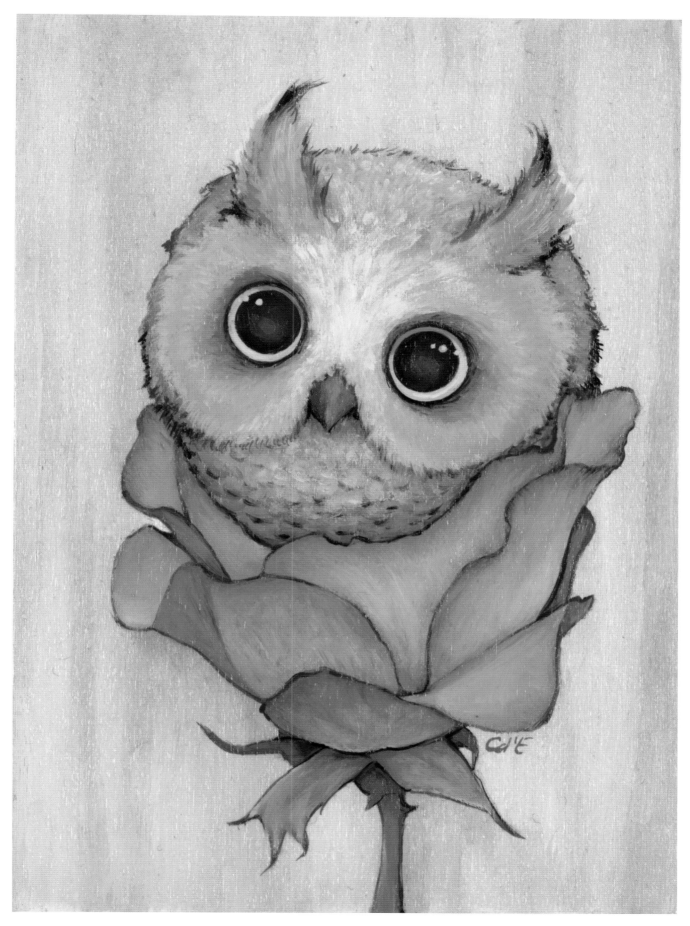

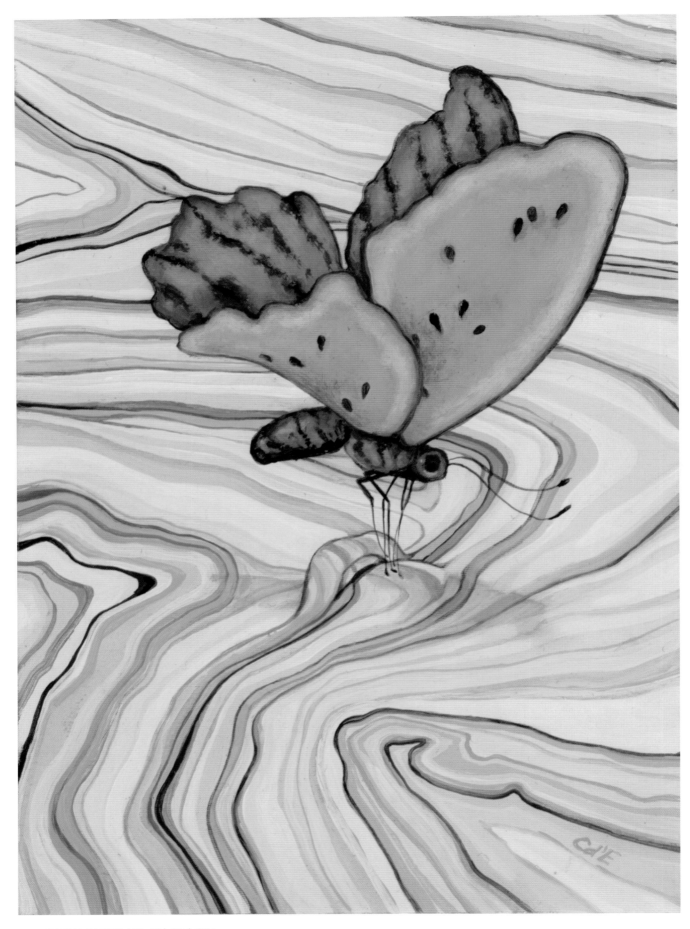

BUTTERFLY KISSES | 5" x 7" | OIL | 2014

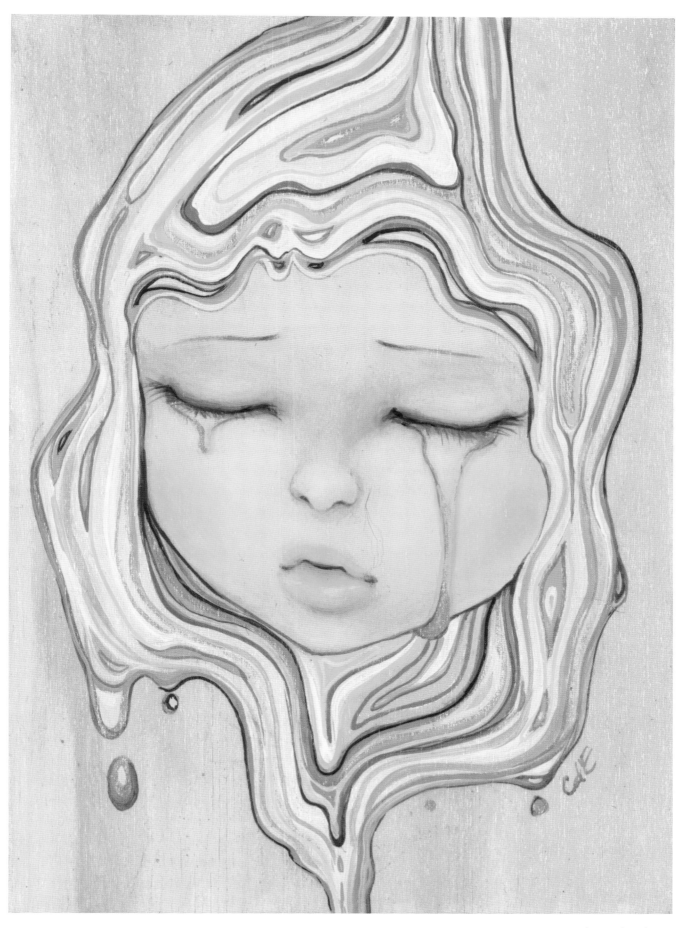

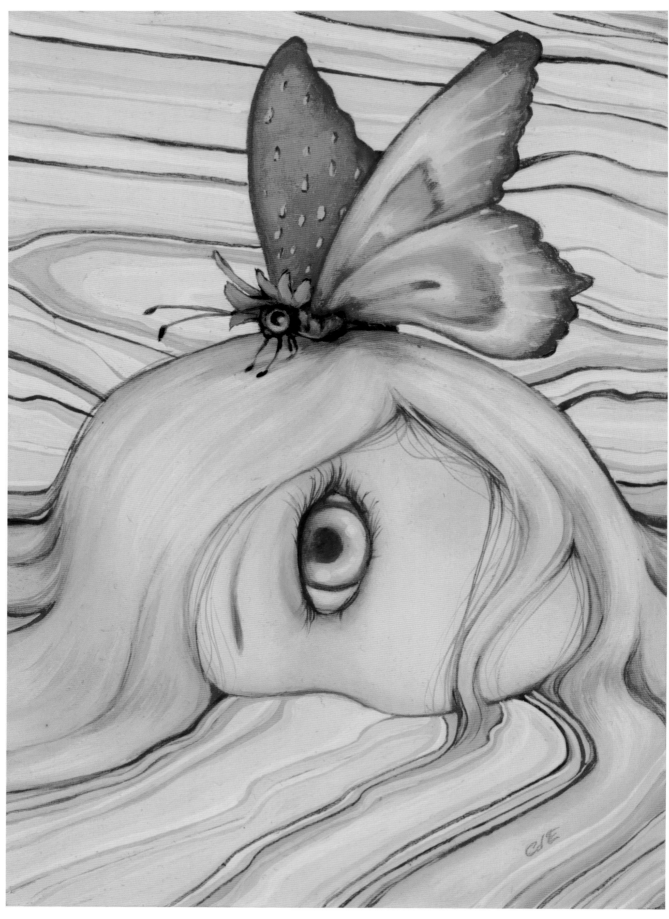

STRAWBERRIES AND SHORTCAKE | 5" x 7" | OIL | 2014

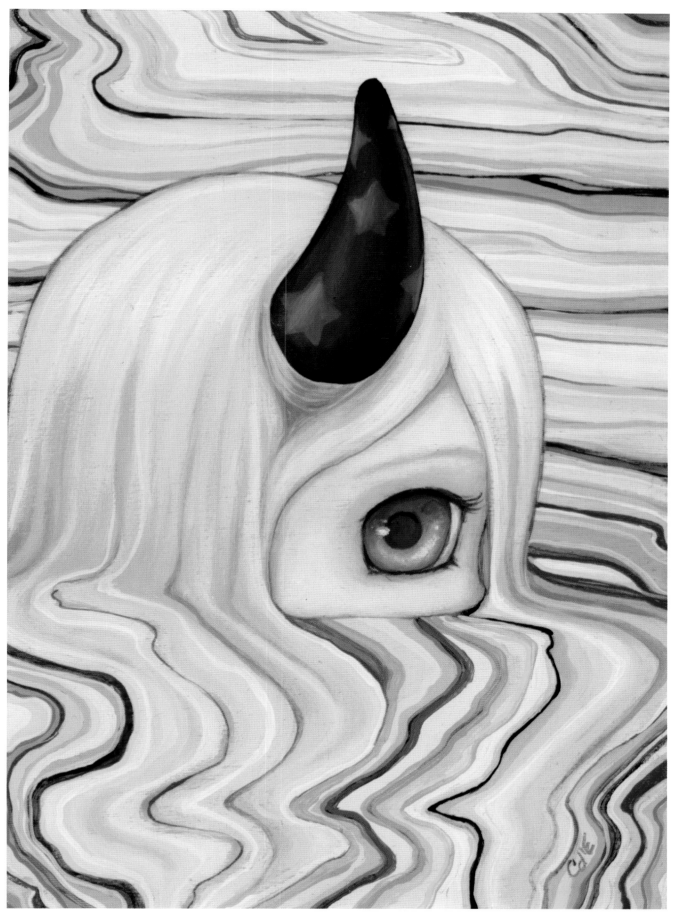

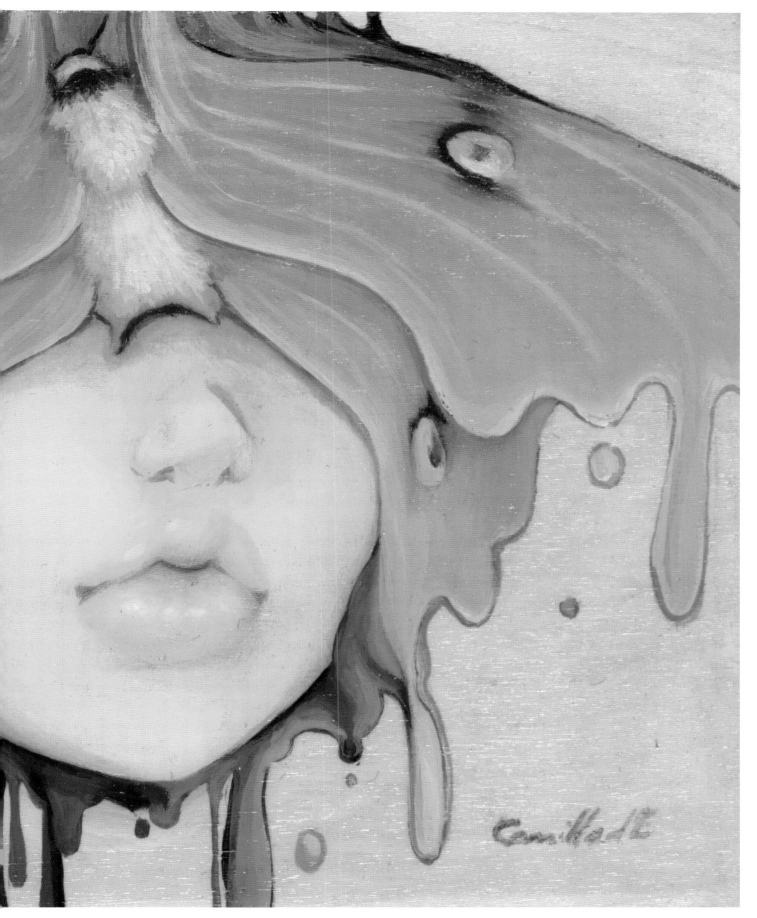

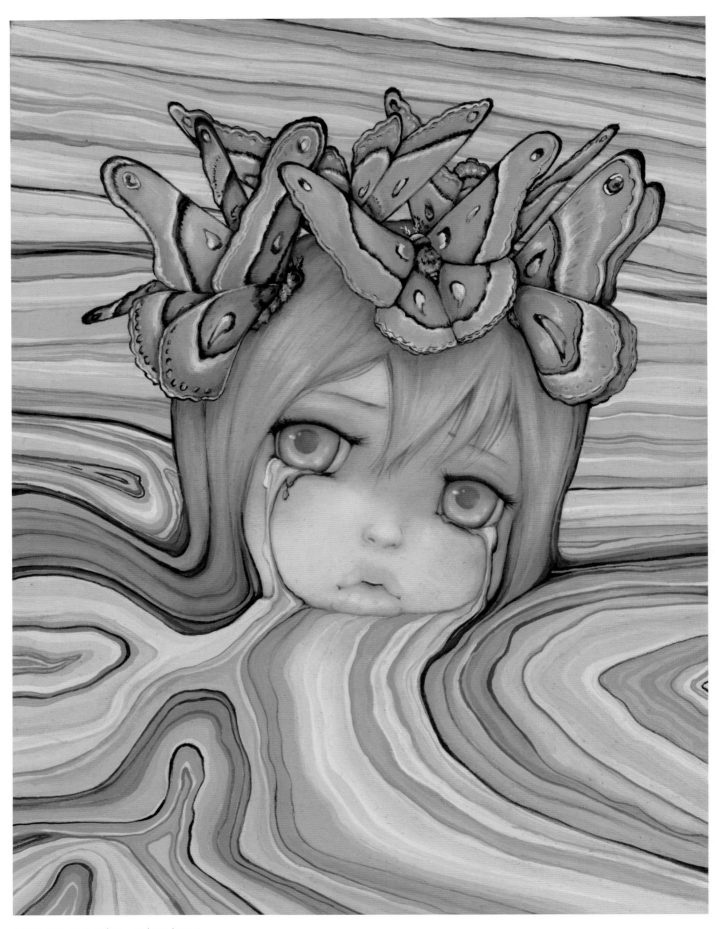

POOL OF TEARS | 9" x 12" | OIL | 2014

NIJI BAMBINI

I WAS HONORED TO BE PART OF THE TWO-PERSON SHOW *NIJI BAMBINI* with Hikari Shimoda at Cotton Candy Machine. Two years after *Candy Escape*, I returned with an array of work that was full of rainbows and colors but different from my previous show. I felt like I'd found my stride at this point. I felt brave and brazen all at once!

Rainbows have become a part of my identity as an artist, and I was excited to explore more of this theme in this body of work. Hikari's art is hypercolorful and incredibly energetic, so I felt like we were a perfect match for each other. We hit the gallery with everything we had!

For the first time I debuted a full-scale painting that featured an animal *only*, with no girl at all! *Rainbuns* was another attempt at pushing my boundaries and comfort zone. I still laugh when I look at it, because the big bunny, Bowser, has this crazy, intense eye.

While I was painting it, I didn't notice it. Now when I look at it I think of Hypnotoad from *Futurama*—I think they'd be best buddies, which makes me giggle.

With *Niji Bambini* (rainbow children), I tried using the rainbows in creative and experimental ways, coloring the animals in many hues and leaving the girls subdued so that they were not the most dominant features of the paintings.

This was a show that got me thinking about how I perceived the space in which my characters existed. They no longer floated in an ambient backdrop but *stood* upon pools of color and melted into their worlds. With each new piece, I found myself exploring the very existence of their universes and imagining myself existing within their laws of physics. In a sense I felt like I became a part of their world, and it was a happy, colorful one that I'd totally live in.

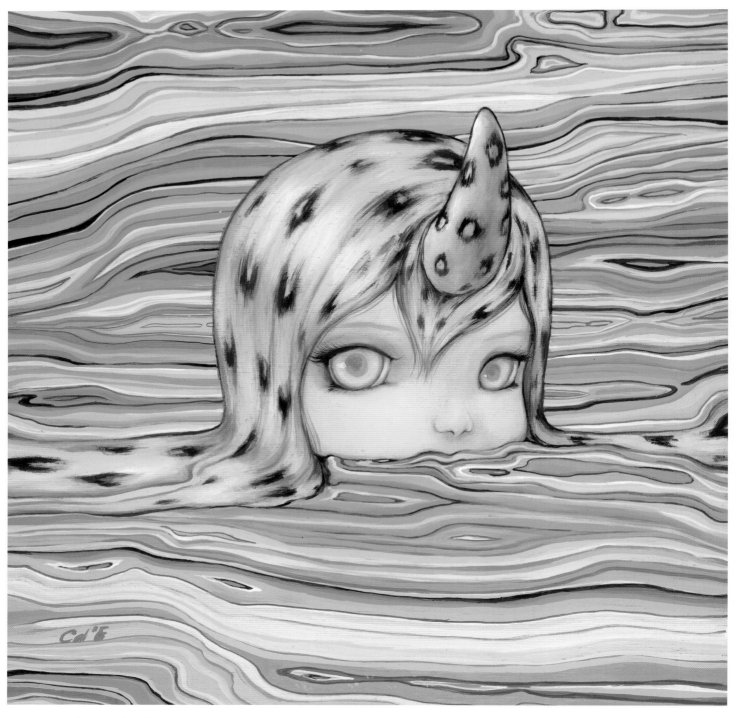

SNOWCORN | 12" x 12" | OIL | 2014

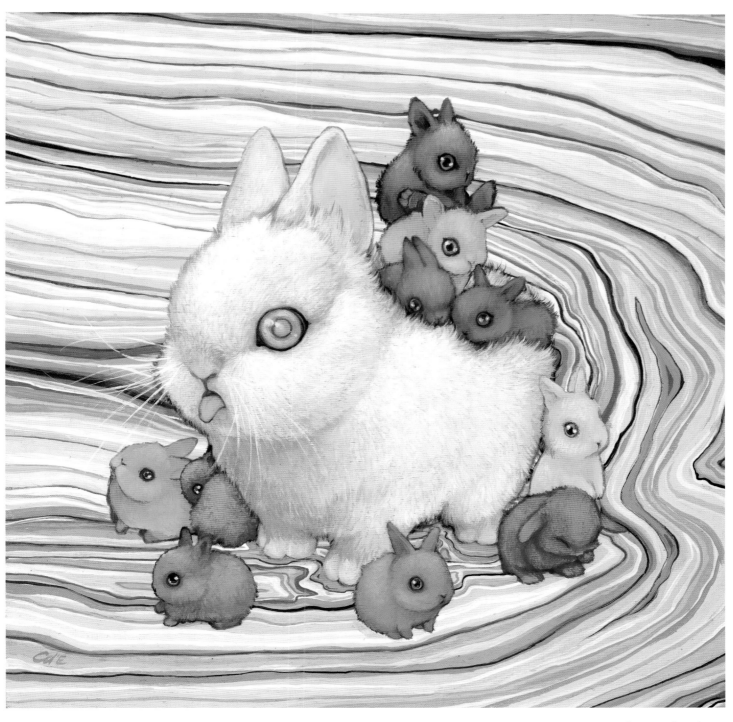

RAINBUNS | 10" x 10" | OIL | 2014

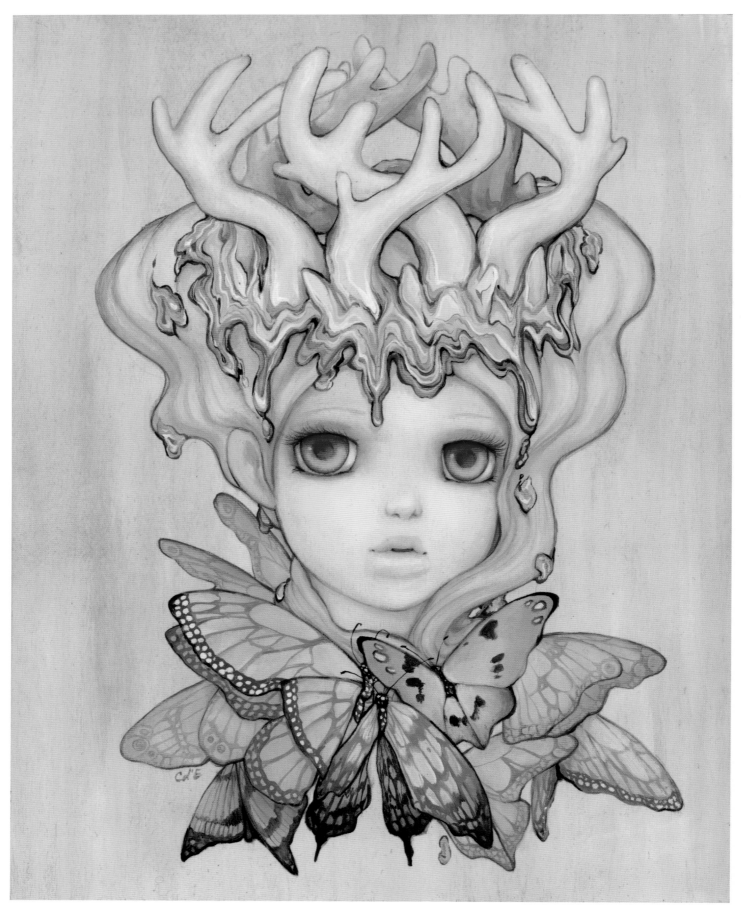

PRINCESS TICKLE TRUNK | 11" x 14" | OIL | 2014

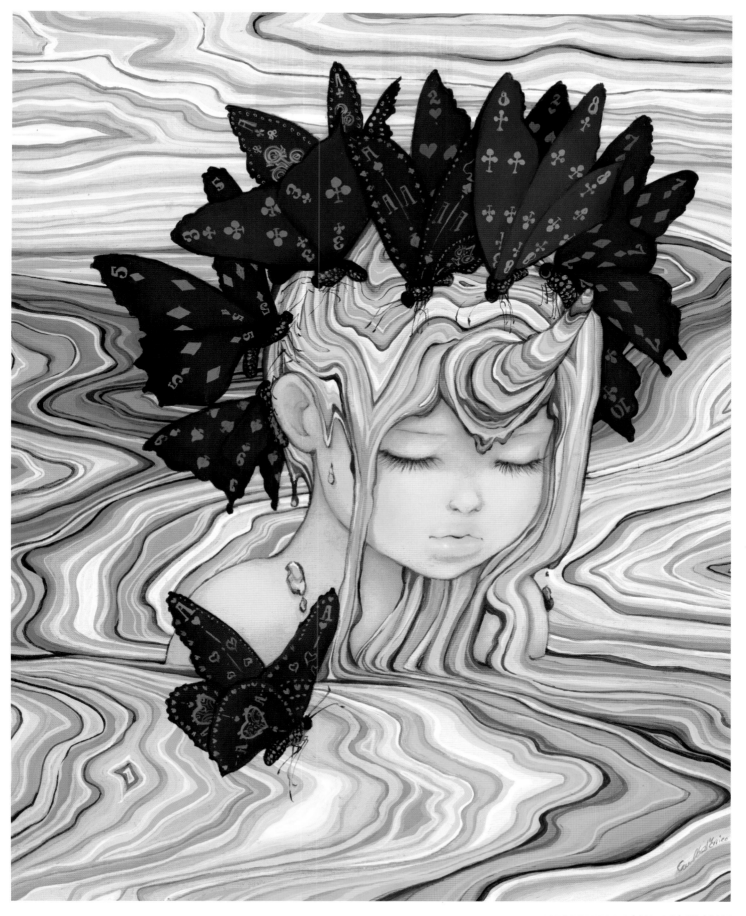

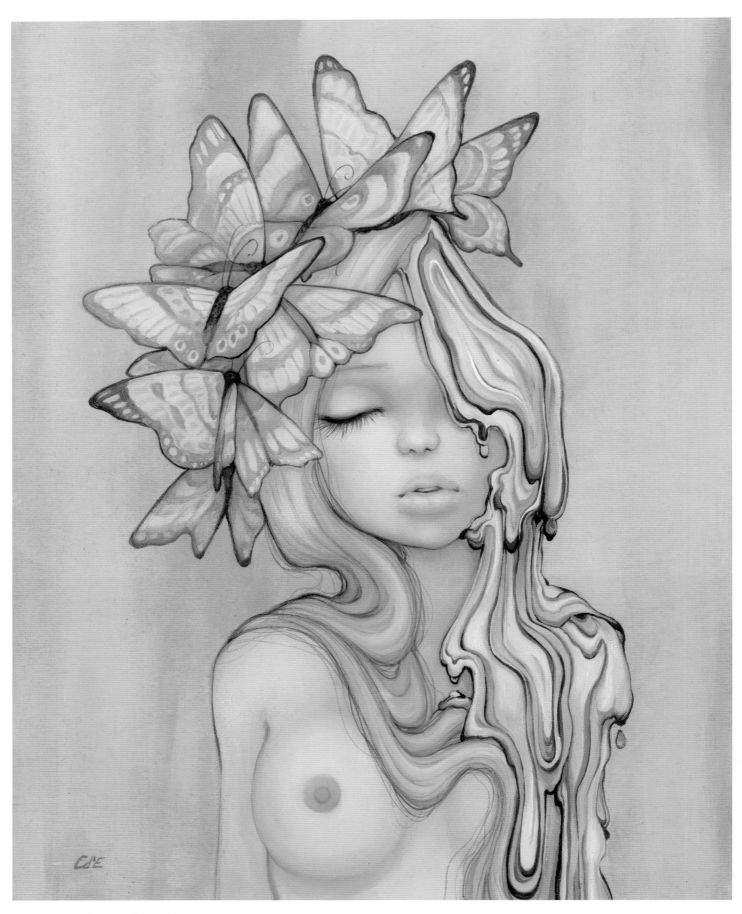

I'M MELTING | 11" x 14" | OIL | 2014

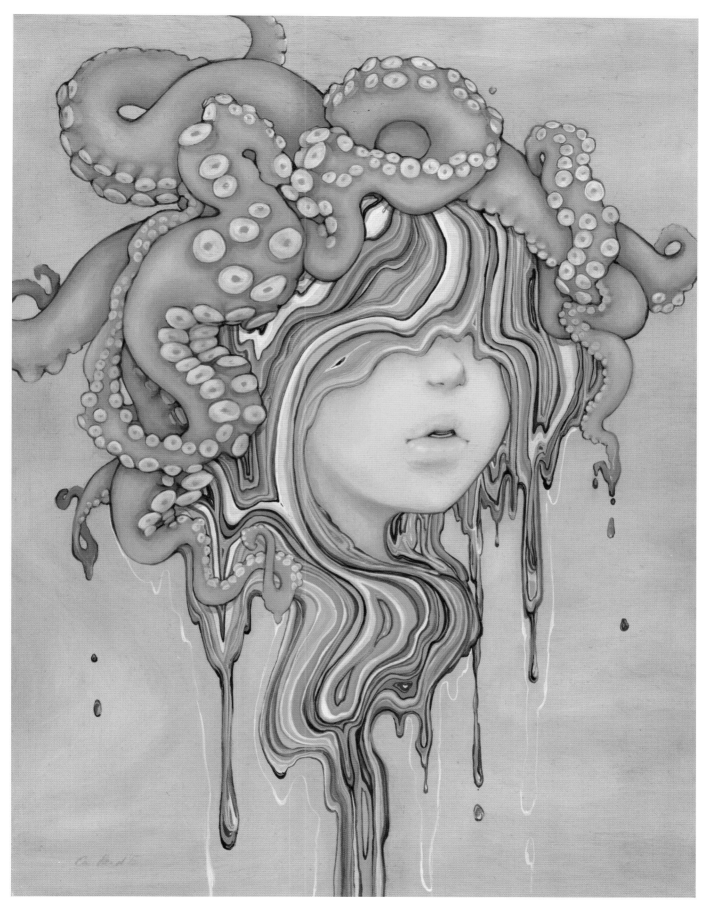

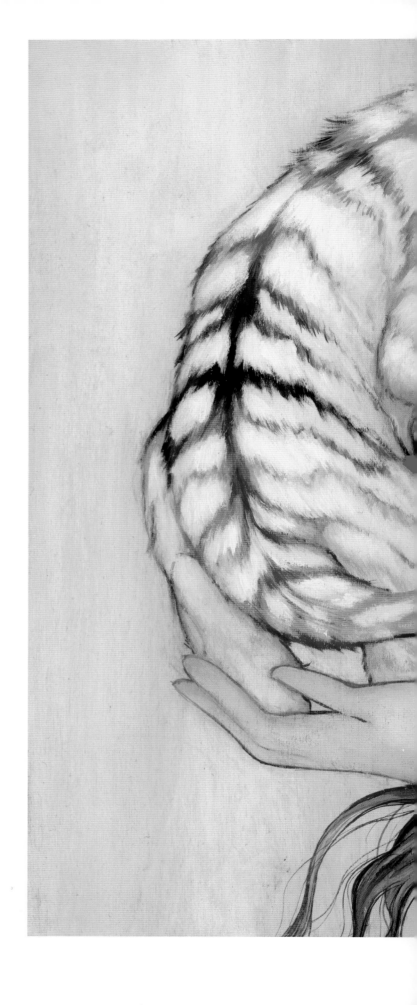

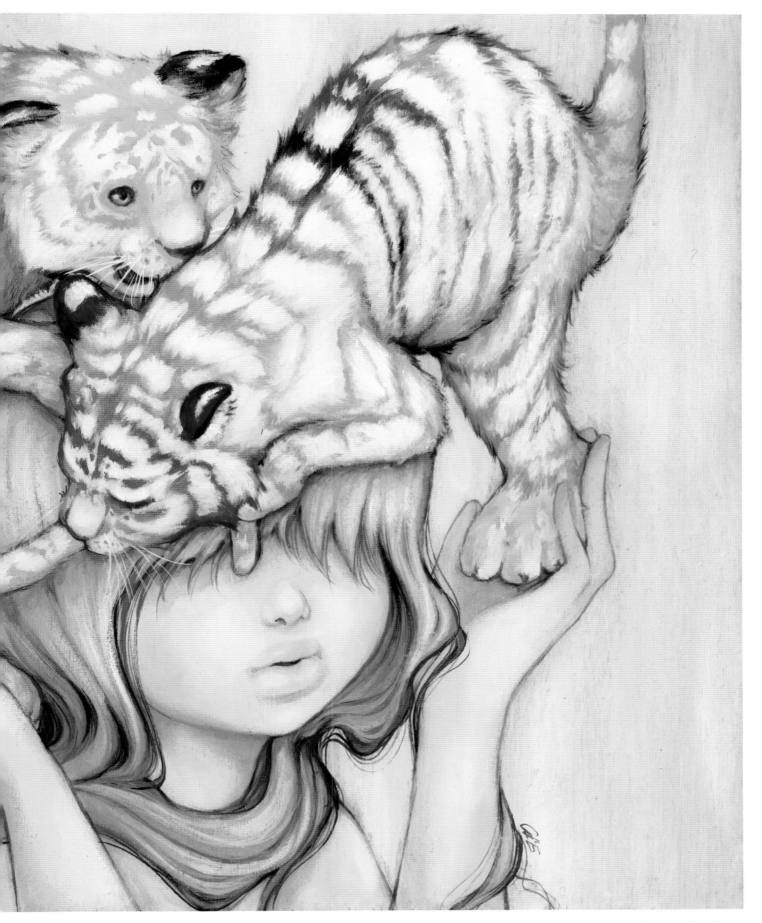

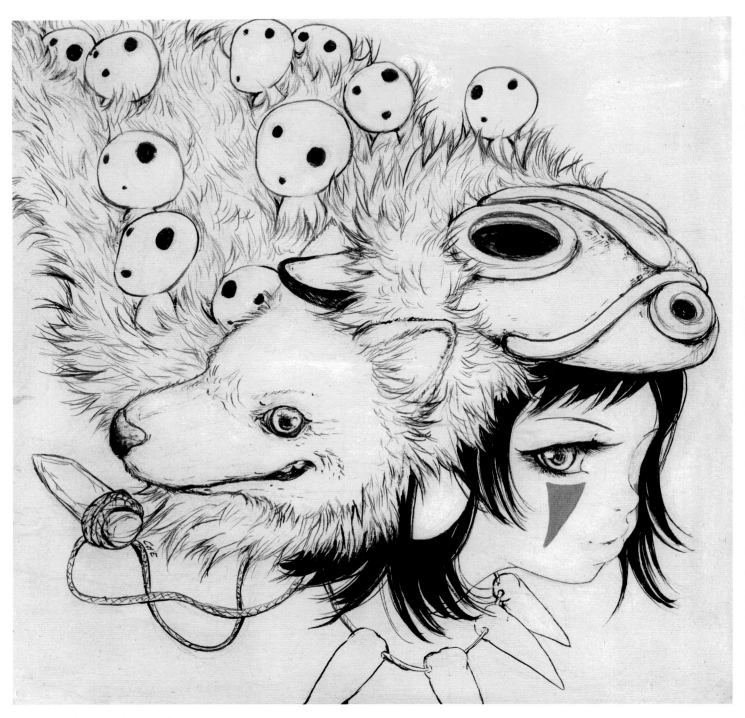

WOLFLING | 12" x 12" | ACRYLIC | 2014

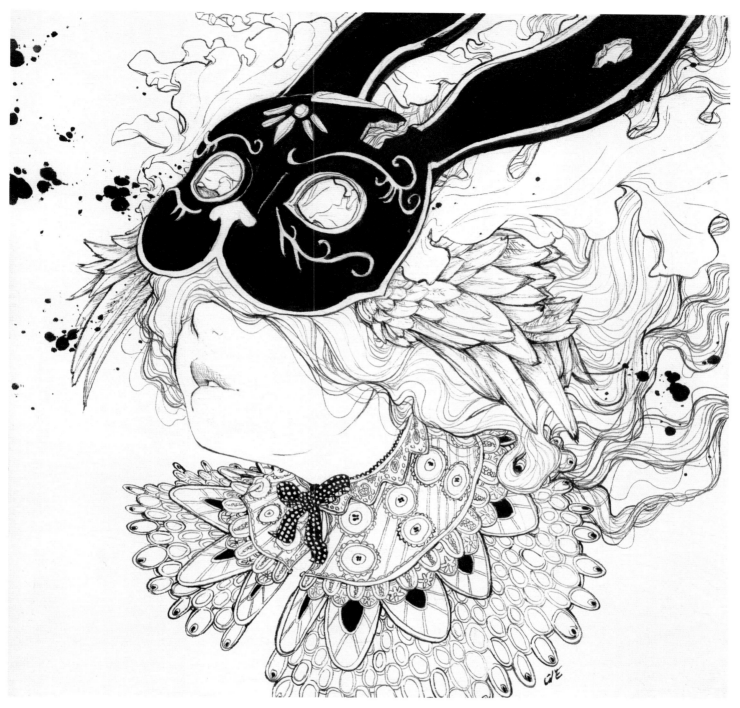

SPLICERIFIC | 12" x 12" | ACRYLIC | 2014

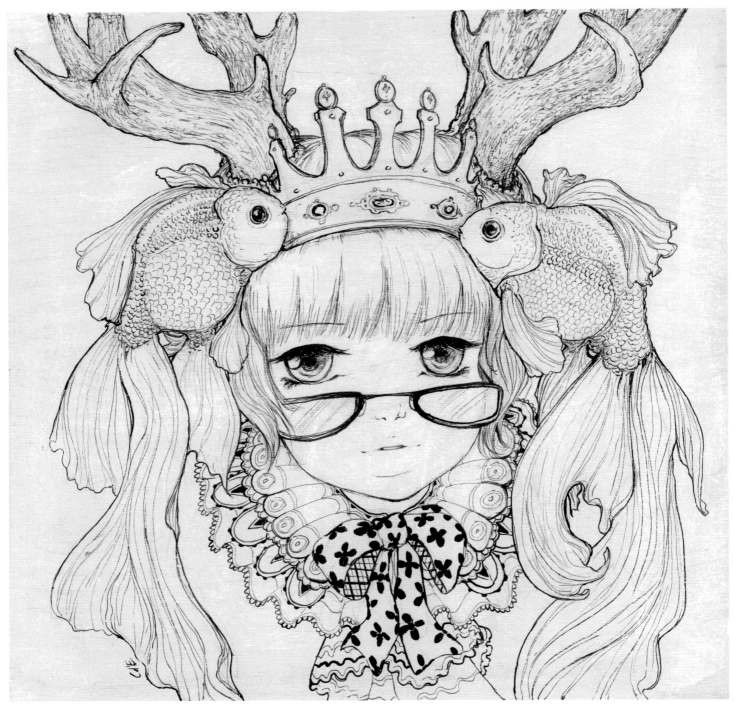

LADY FAN TAIL | 12" x 12" | ACRYLIC | 2014

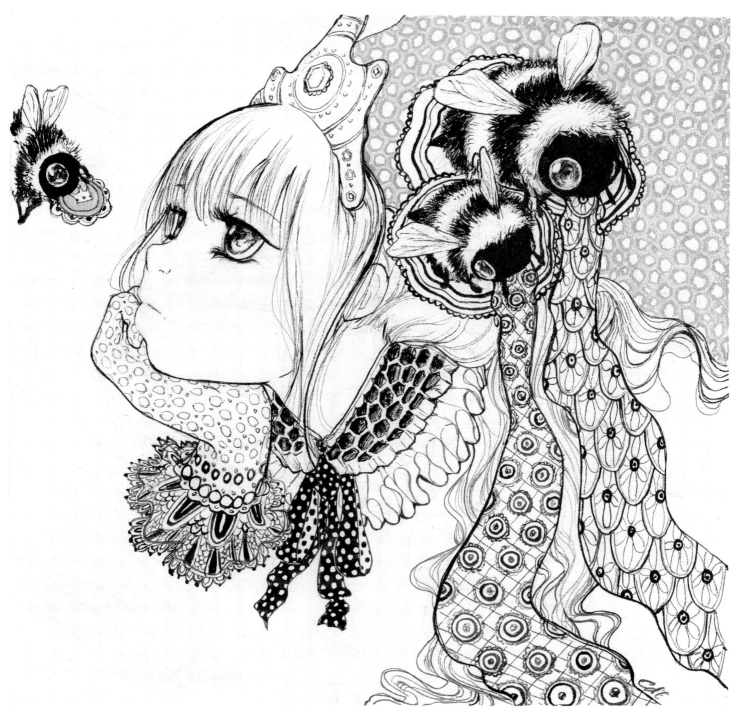

BUTTERCUP | 12" x 12" | ACRYLIC | 2014

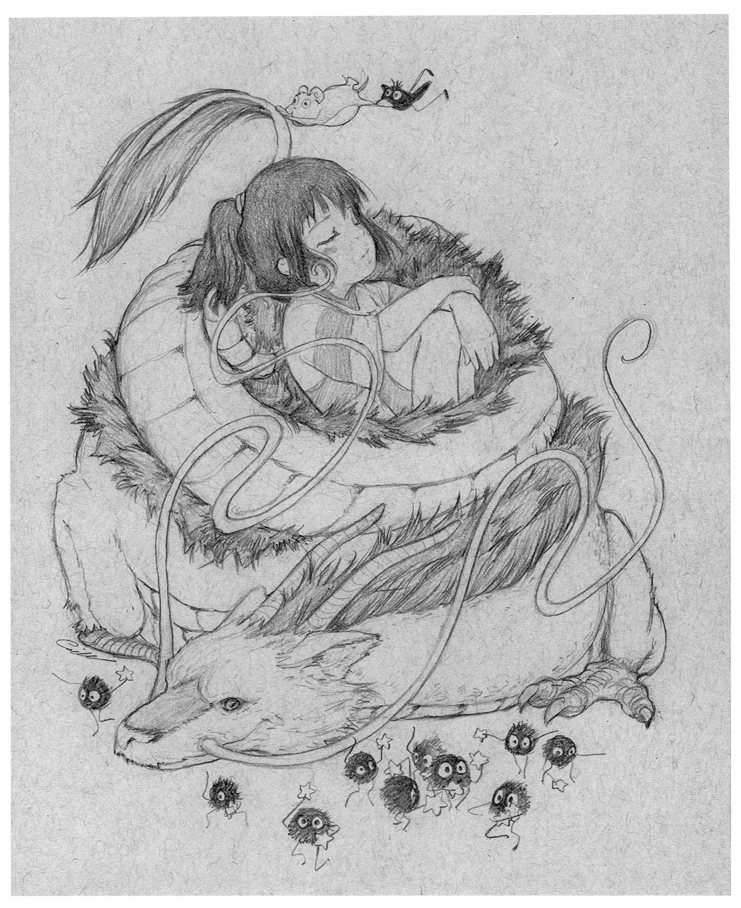

CHIHAKU | 8" x 10" | GRAPHITE | 2014

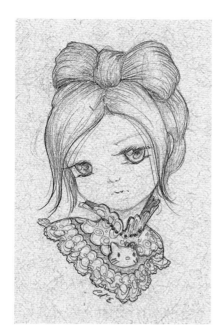
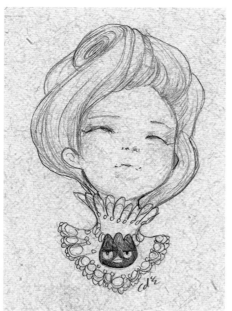
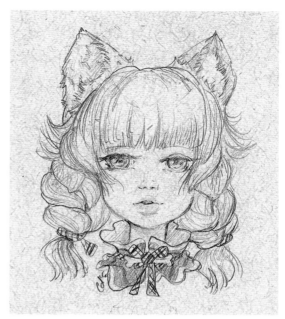
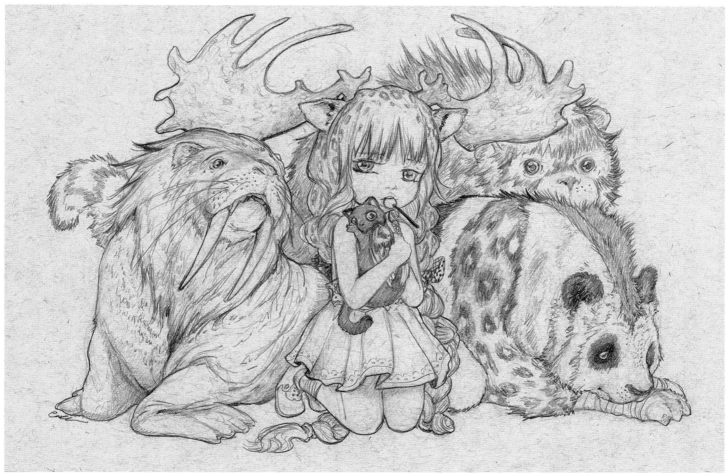

THE CAT LADY | 4" x 6" | GRAPHITE | 2014
XO | 3" x 5" | GRAPHITE | 2014
WOLFIE | 4" x 6" | GRAPHITE | 2014
LOLLIKINS | 12" x 8" | GRAPHITE | 2014

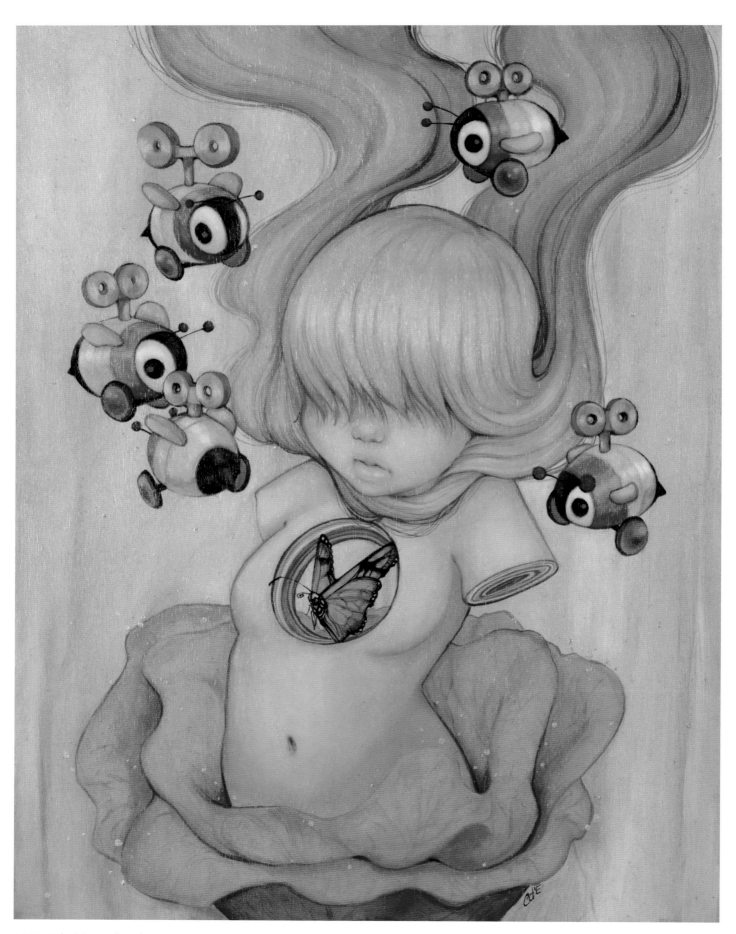

"I went back to my roots and used themes from past works—but as I saw them now, as my present self."

BEAUTY IN THE BREAKDOWN

WHILE ORGANIZING *BEAUTY IN THE BREAKDOWN* I was astounded to realize this would be my ten-year painting anniversary. I honestly can't believe it's been *that* long; it seems like I blinked and a decade went rolling by.

This was a very special two-person show by Sarah Joncas and me. It was held at Thinkspace Gallery in Los Angeles, where we first showed together. My very first US gallery exhibition way back in 2008 was with Sarah, so it ended up being a reunion show that we both were very excited for.

The pieces I chose to create were an homage to my journey as a gallery artist. It's a funny thing to look back on ten years and see just how much you've changed. I noticed that every piece of art I created in that time frame told a little individual story about who I was and what I was going through emotionally. When I looked at my paintings from the start of my career right up to my latest show, I could recall every single moment of painting those images, as if they were a Netflix series I could marathon.

My intention with this particular body of work was to create a proverbial "thread" that would tie my past, present, and future together. I mixed my imagery up, tossed ideas and concepts into a creative bowl, and blended it together. I went back to my roots and used themes from past works—but as I saw them *now*, as my present self. My thoughts on love and friendship and ideas about the soul and passion are very different now, compared to what they were ten years ago. So I wanted to reflect that with these paintings.

There were some elements in these works that came from a side of myself that I believe has matured over the last decade; they have never been reflected in my paintings before now. I tried pushing forward creatively while still honoring my past essence. I feel like this series really encompassed who I am as an artist, as someone who has grown over the years and stayed true to who they are despite the passage of time.

On a funny, crazy note, I was twenty-four when I had my first art show, and by sheer luck I created twenty-four pieces for this exhibition . . . Coincidence or fate? I like to think that my subconscious did it on purpose.

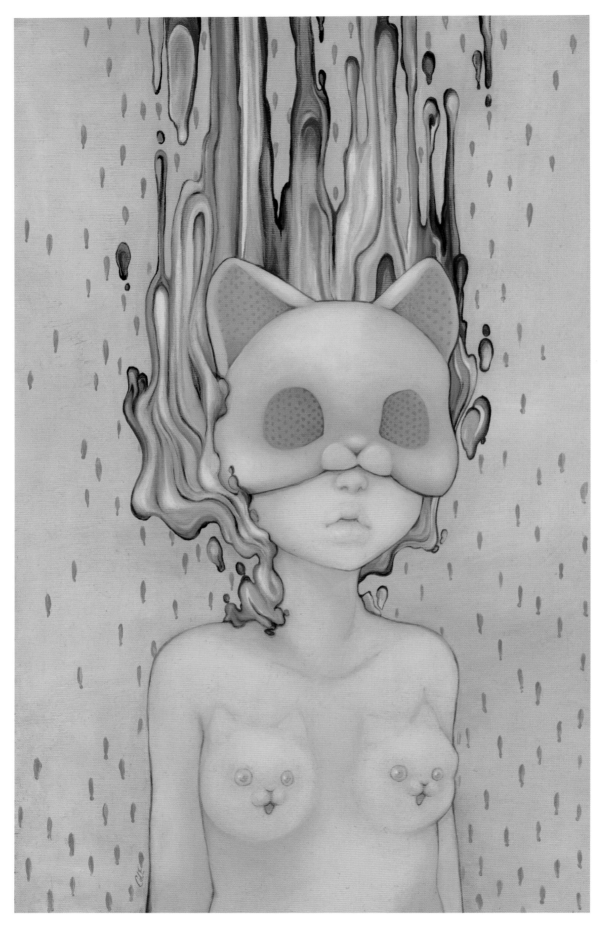

KITTY TITTIES | 12½" x 20" | OIL | 2015

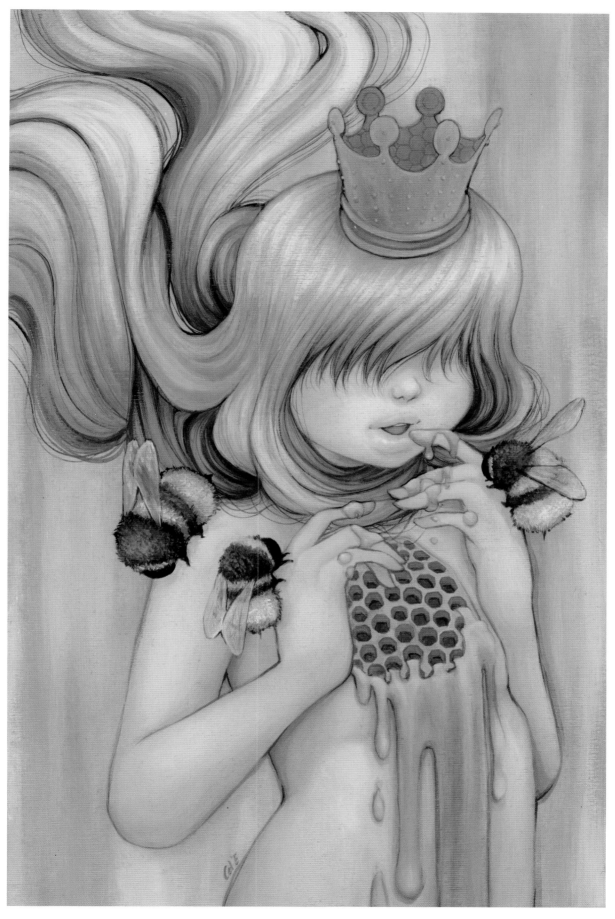

QUEEN BEATRICE | 10½" x 15²/₅" | OIL | 2015

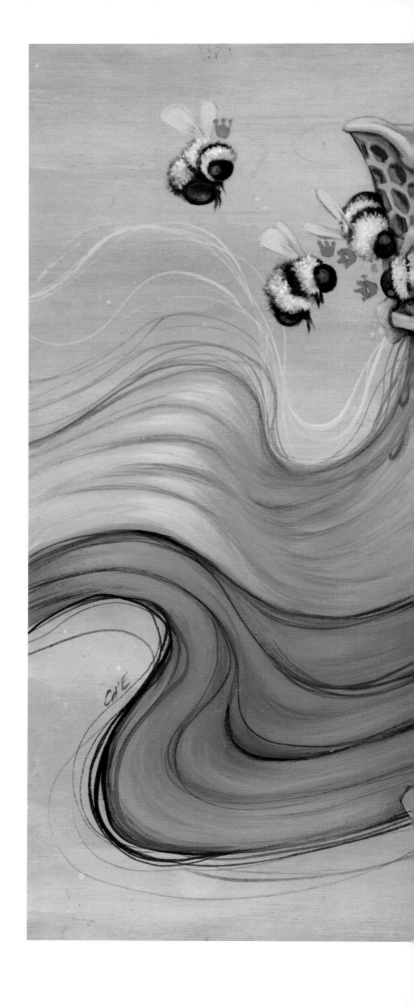

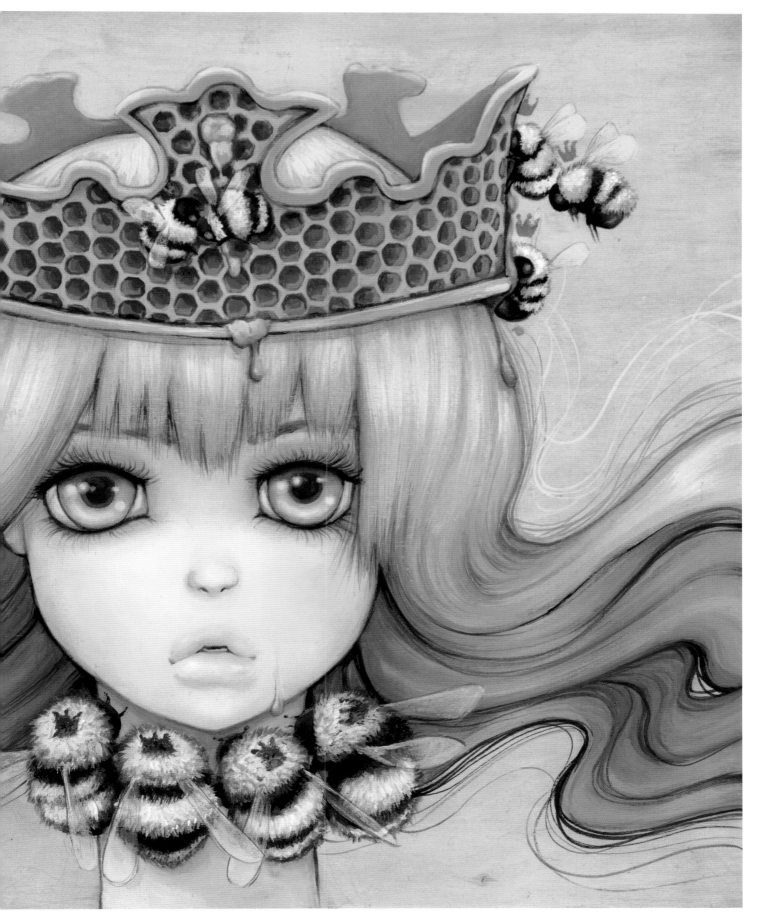

ROYAL JELLY | 14" x 11" | OIL | 2015

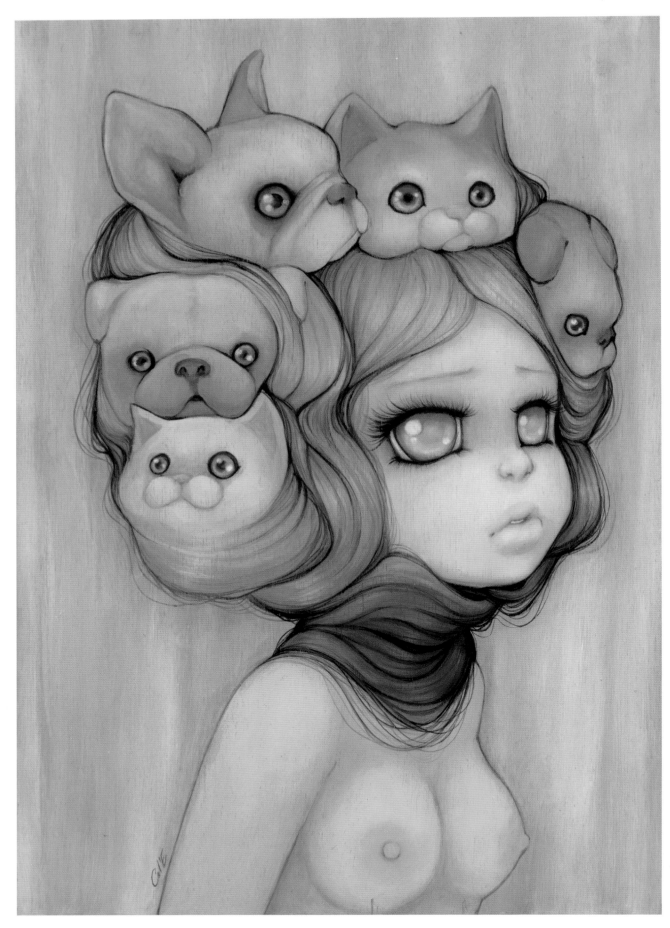

MADEMOISELLE GATTO | 11" x 14" | OIL | 2015

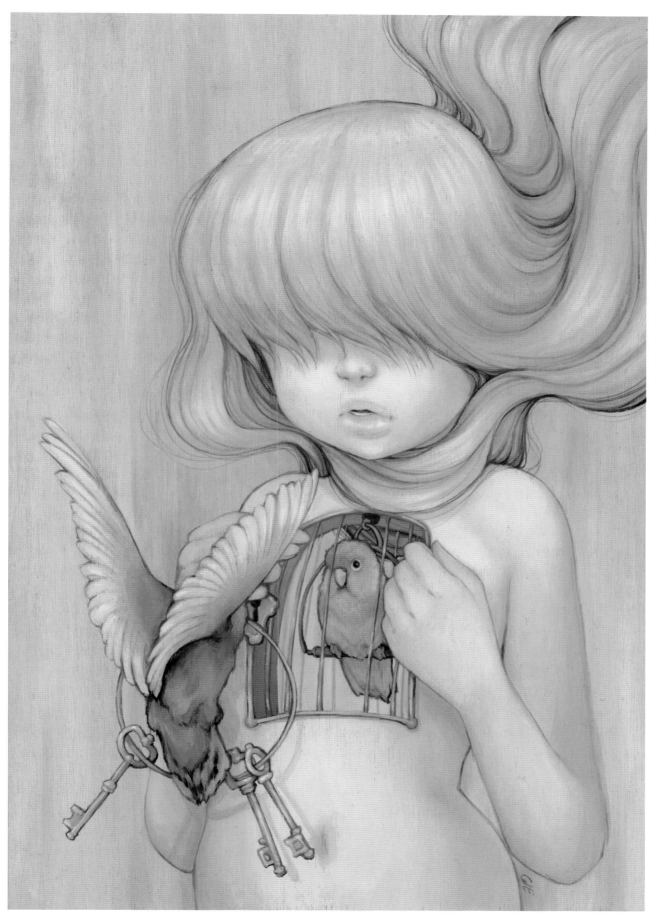

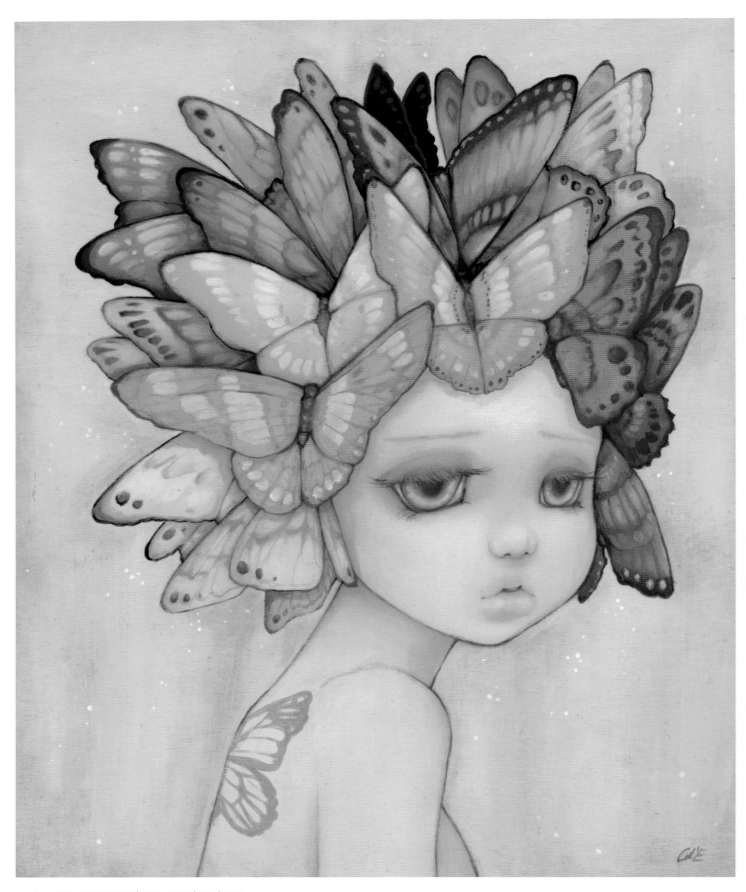

MADAME BUTTERFLY | 9¾" x 11¾" | OIL | 2015

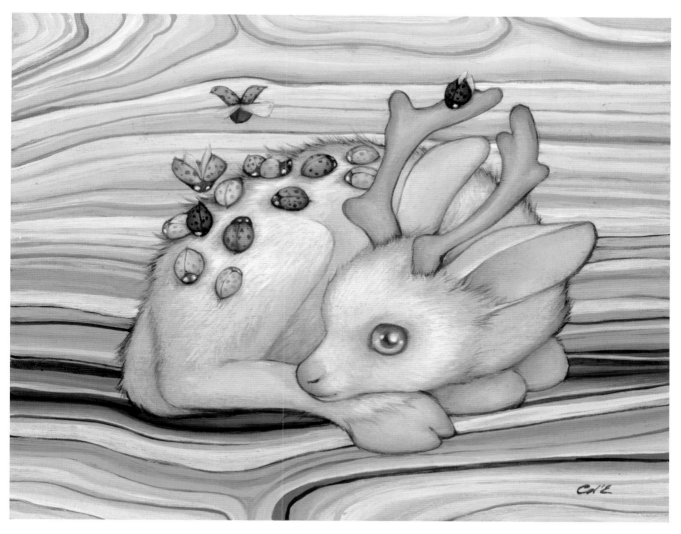

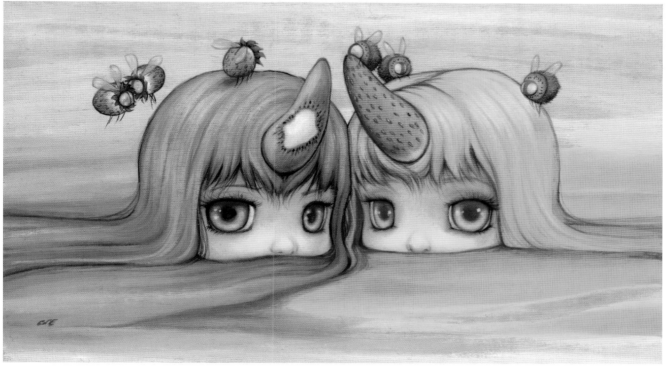

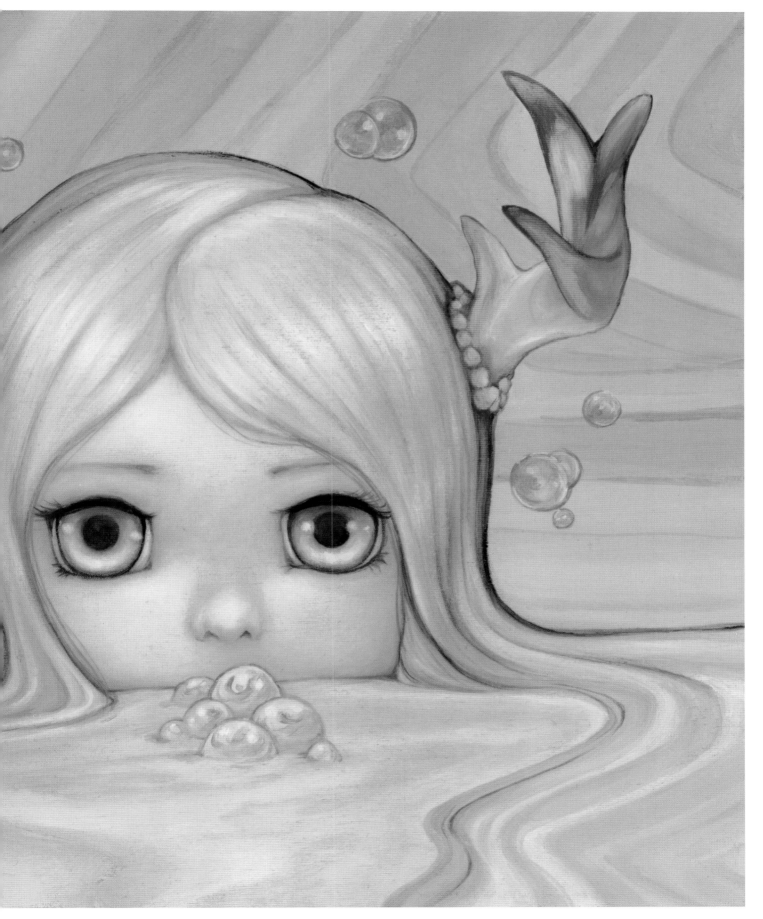

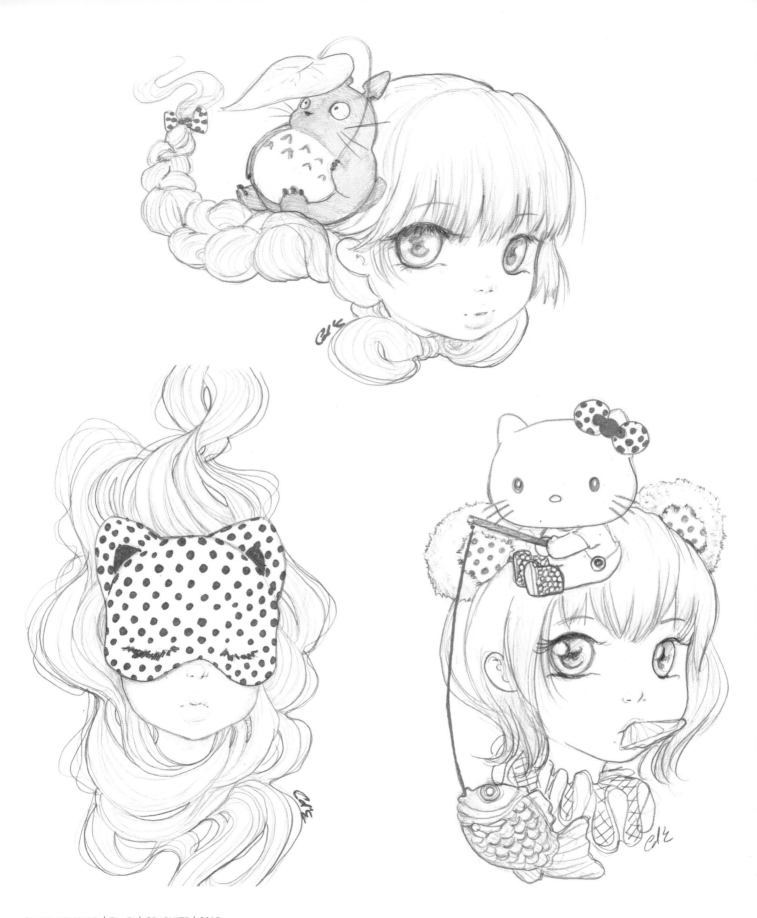

SUNBATHING | 7" x 5" | GRAPHITE | 2015
MRS. GATTI | 5" x 7" | GRAPHITE | 2015
GONE FISHING | 5" x 7" | GRAPHITE | 2015

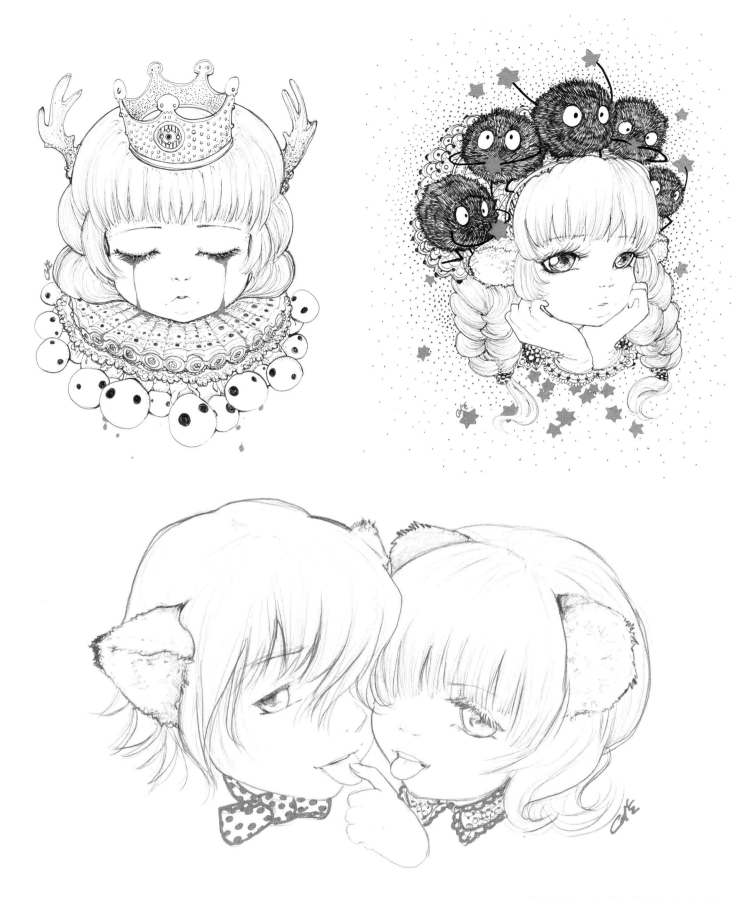

TREE OF LIFE | 8" x 10" | GRAPHITE | 2015
SOOT'S AWAY! | 8" x 10" | GRAPHITE | 2015
TONGUE TIED | 7" x 5" | GRAPHITE | 2015

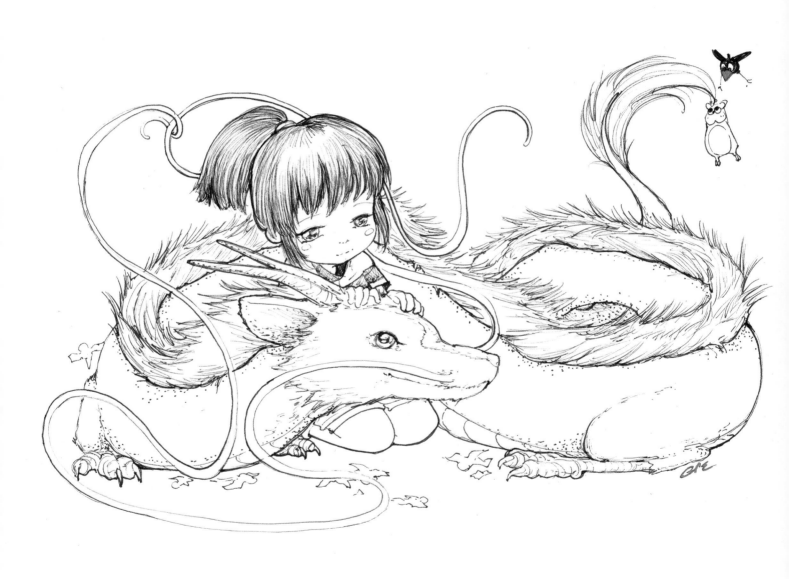

PAPER HEARTS | 10" x 8" | GRAPHITE | 2015

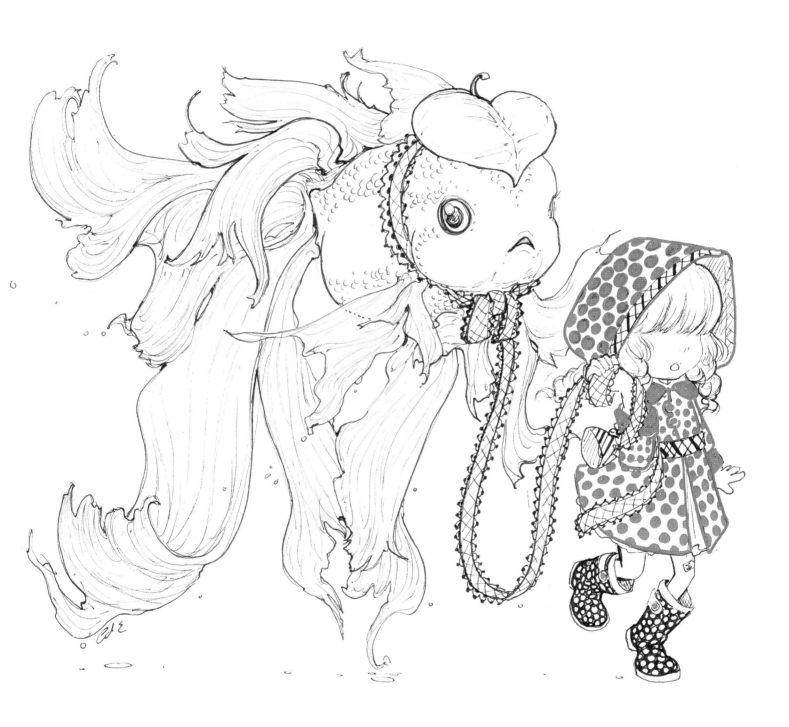

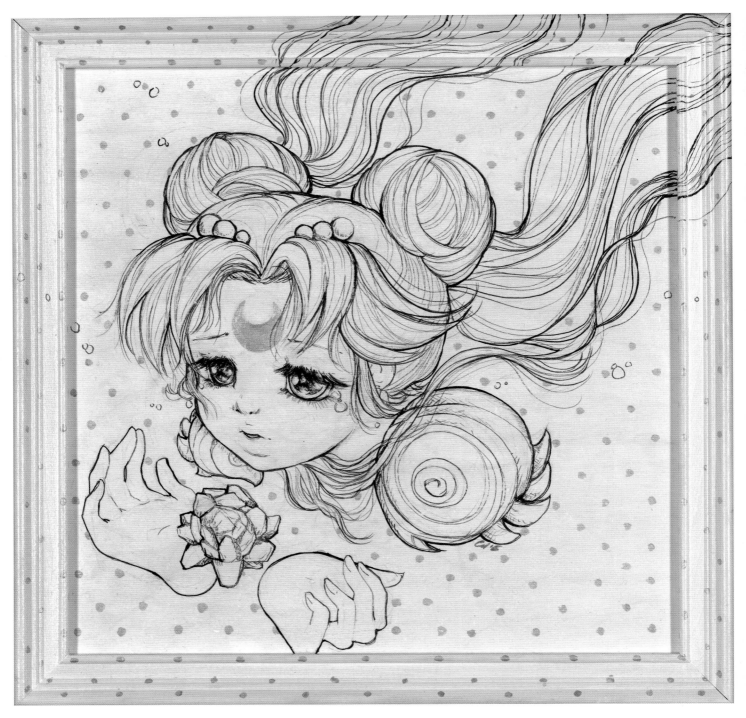

SERENITY NOW | 12" x 12" | ACRYLIC | 2015

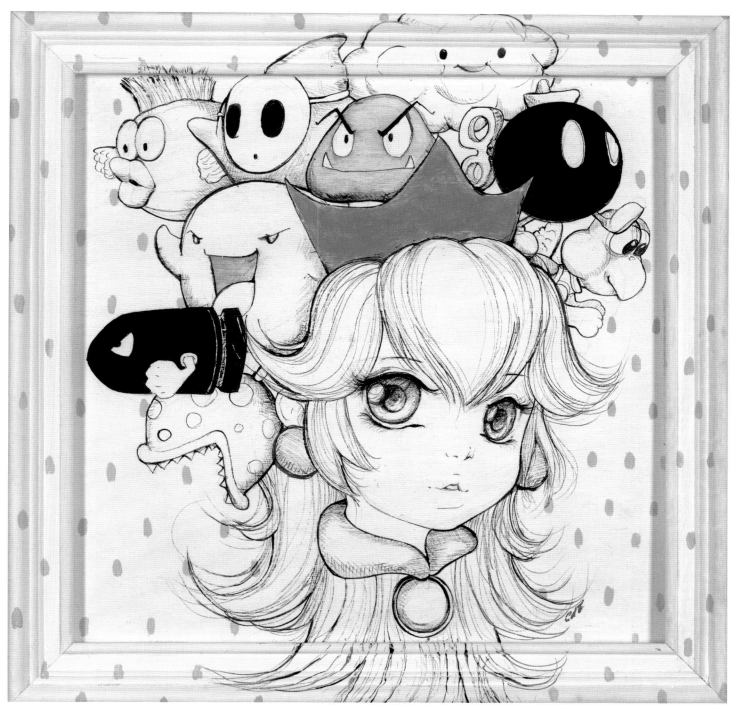

PEACH PIE | 10T" x 10" | ACRYLIC | 2015

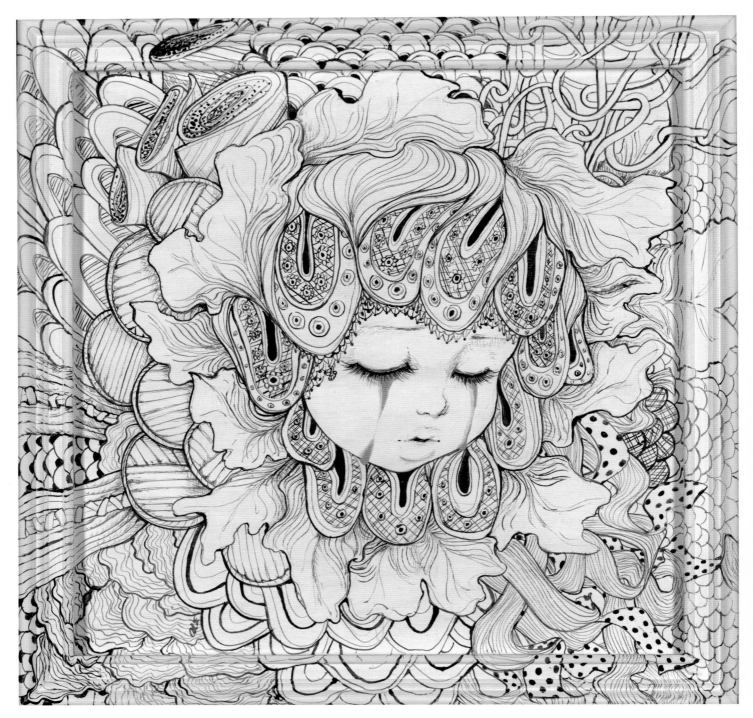

CHARLIE | 12" x 12" | ACRYLIC | 2015

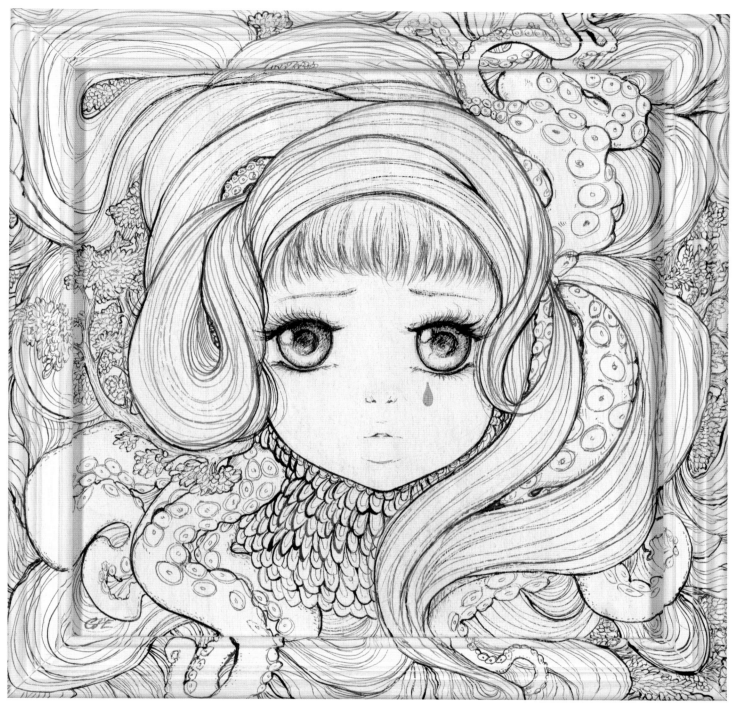

GARDENIA | 10" x 10" | ACRYLIC | 2015

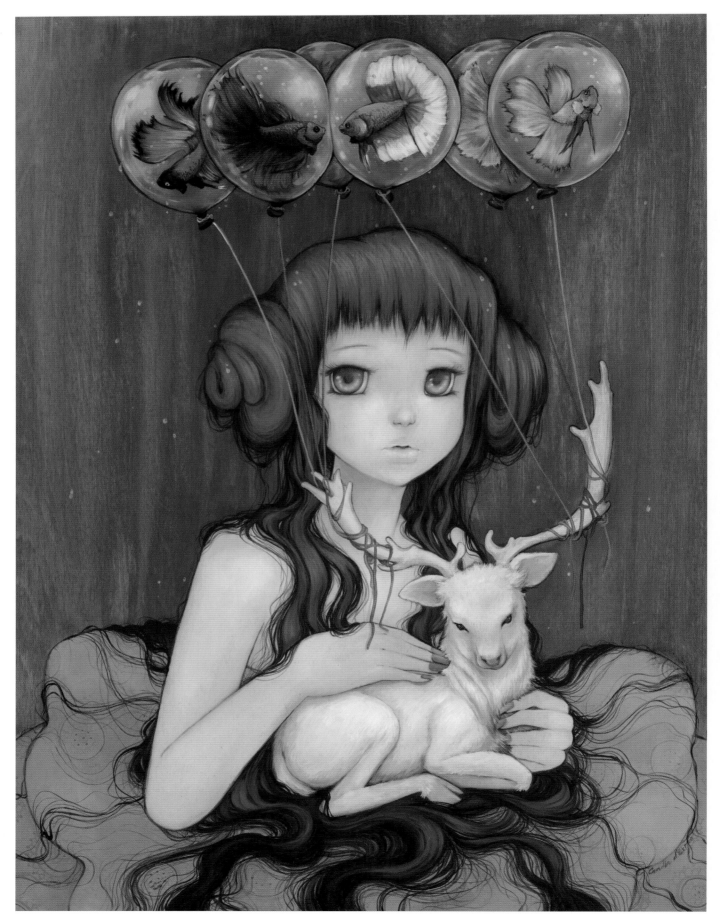

UNPREDICTABLE GRAVITY | UNPREDICTABLE GRAVITY | 18" x 24" | OIL | 2014

GROUP SHOWS

THIS CHAPTER COLLECTS MANY OF MY PAINTINGS FROM GROUP ART SHOWS. If you're wondering what a group show is, I'll tell ya! Galleries will often hold exhibitions where they invite a few dozen artists to create artwork that will be exhibited together. The galleries might have a specific theme, or they might choose a size they want the artists to work with. It's a fun way to try something that you already love doing or that you normally might not have considered attempting.

I'm a huge fan of Hello Kitty (obviously), so I pounce at any opportunity to get to paint the cute little kitty or her friends. There are lots of shows that are based on pop culture, which really fits in with the pop surrealism art movement. I love being part of these shows because I can do a painting inspired by *My Little Pony* or a character from my favorite movie and interpret it in my own way.

A huge part of these types of shows for me is seeing what other artists create. Seeing how others are inspired by pop culture and translate it to their style is an unbelievable thing. Getting to see how Audrey Kawasaki paints Hello Kitty or how Greg Simkins interprets Mickey Mouse interests me to no end. I'm such a nerd for this stuff. It's ridiculous.

You will see a wide range of artwork in this chapter, and I hope you enjoy my interpretations and paintings of some of today's most famous pop culture icons.

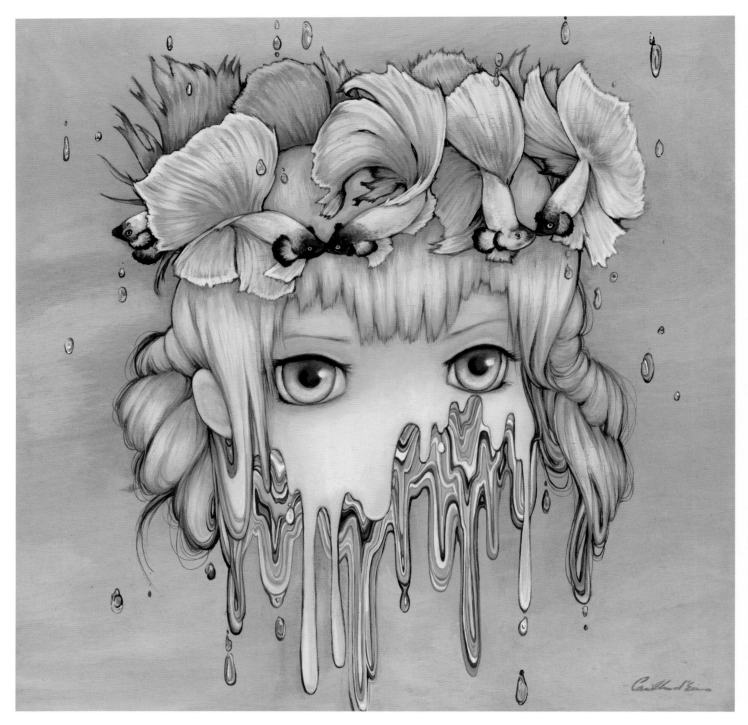

THINKSPACE GALLERY: LAX/TXL | **LOVER'S QUARREL** | 16" x 16" | OIL | 2014

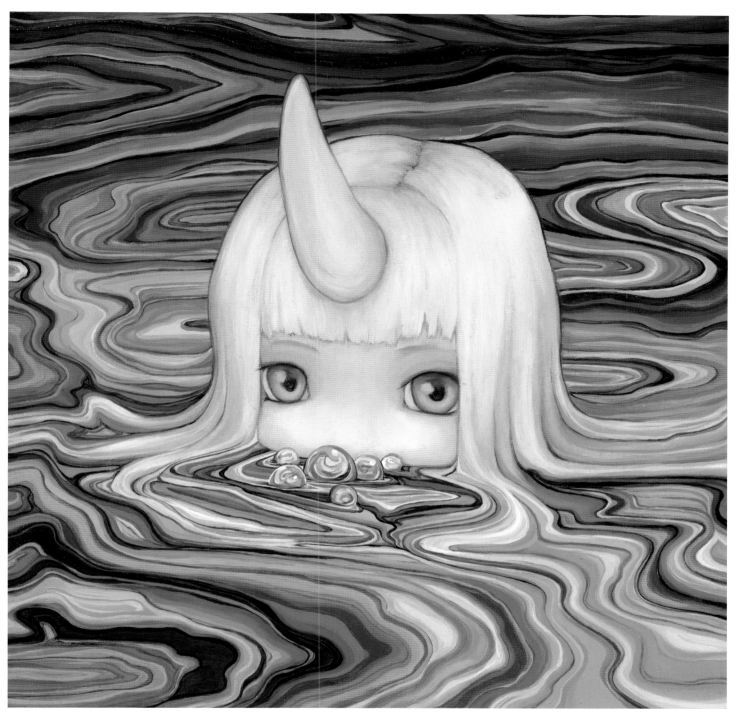

ART COLLECTOR STARTER KIT 1 | BUBS | 12" x 12" | OIL | 2013

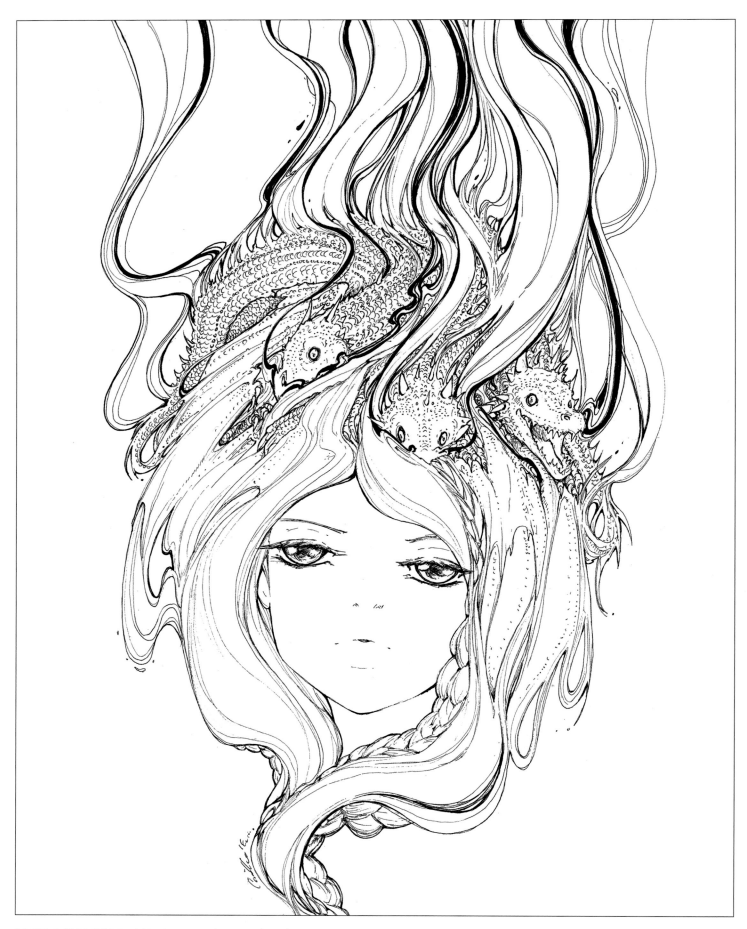

WINTER IS COMING | DRAGON'S HEART | 11" x 14" | INK | 2013

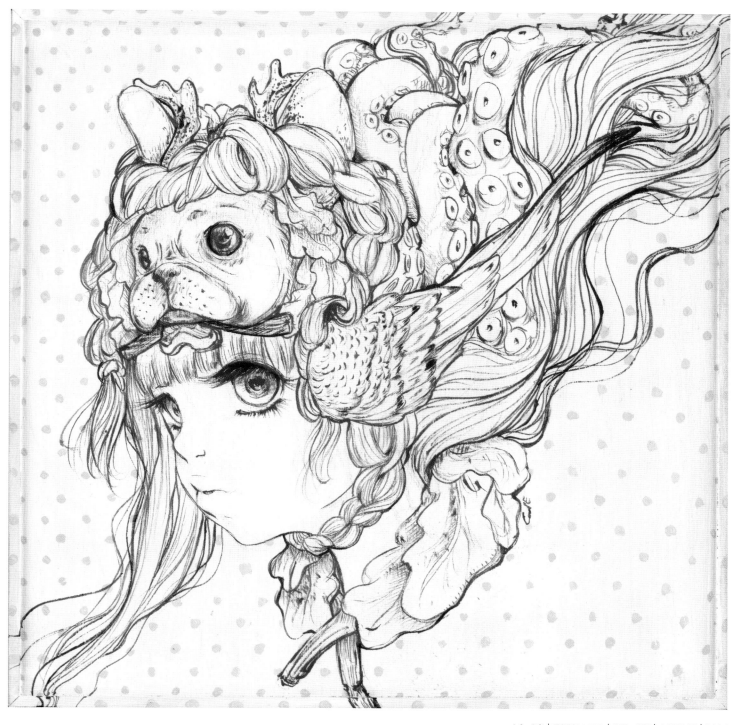

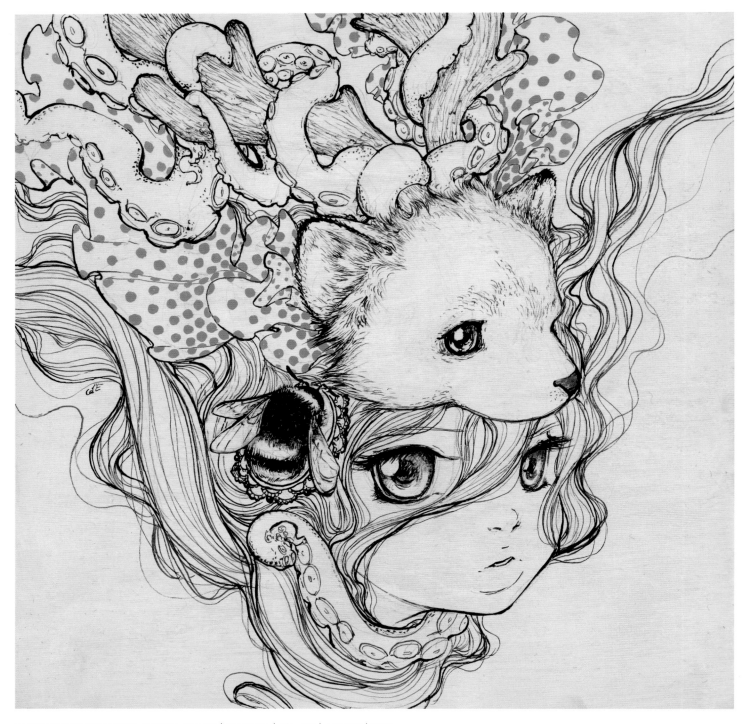

THINKSPACE GALLERY: SCOPE MIAMI | **FURBEE** | 10" x 10" | ACRYLIC | 2014

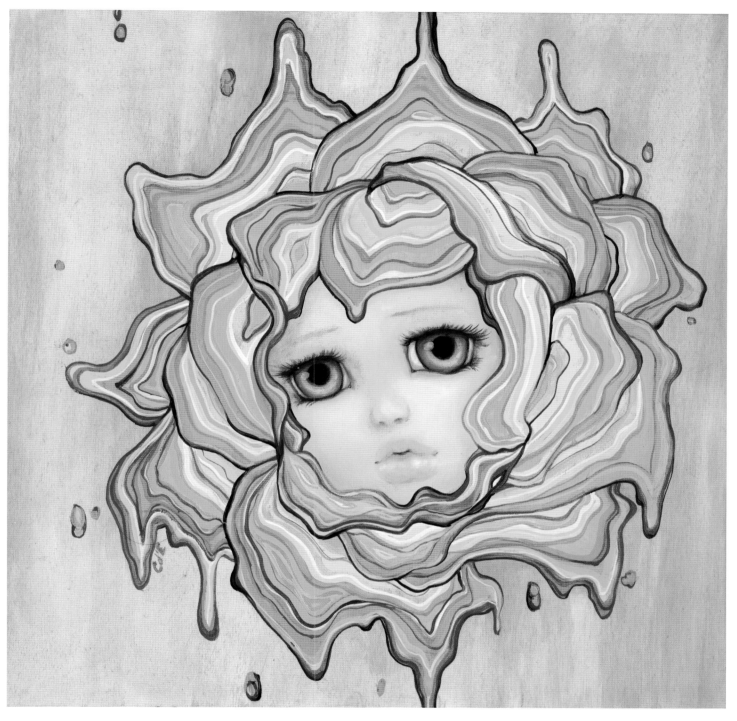

ART COLLECTOR STARTER KIT 2 | BUTTERBLOSSOM | 12" x 12" | OIL | 2014

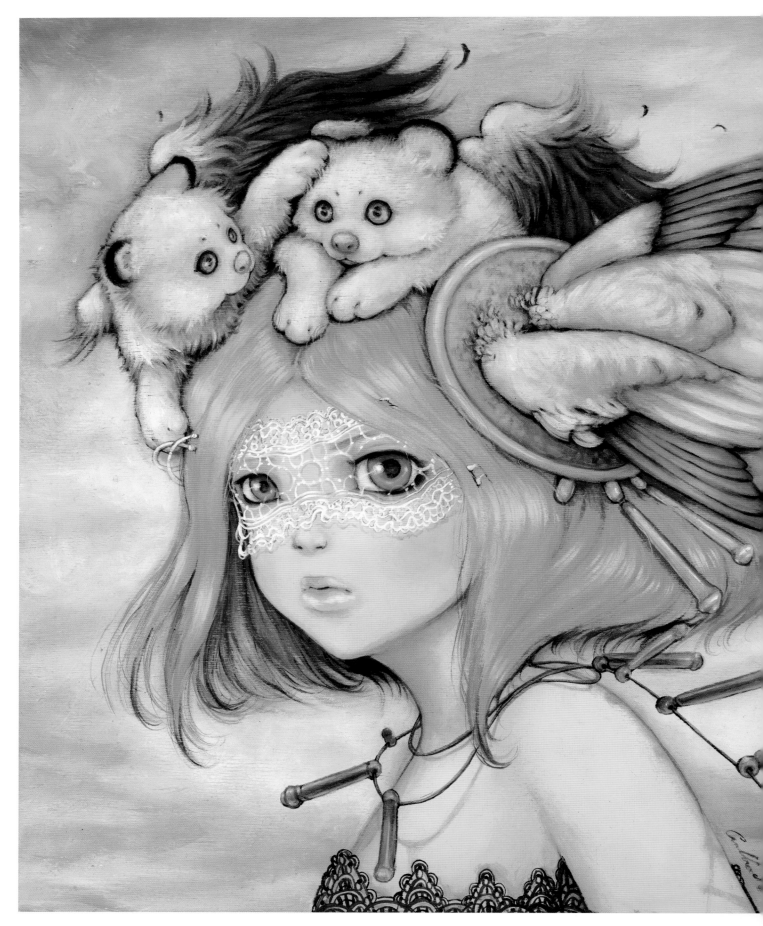

SKY PIRATES OF NEO TERRA PAINTING COMMISSION | GRASSLAND GODDESS | 20" x 16" | OIL | 2012

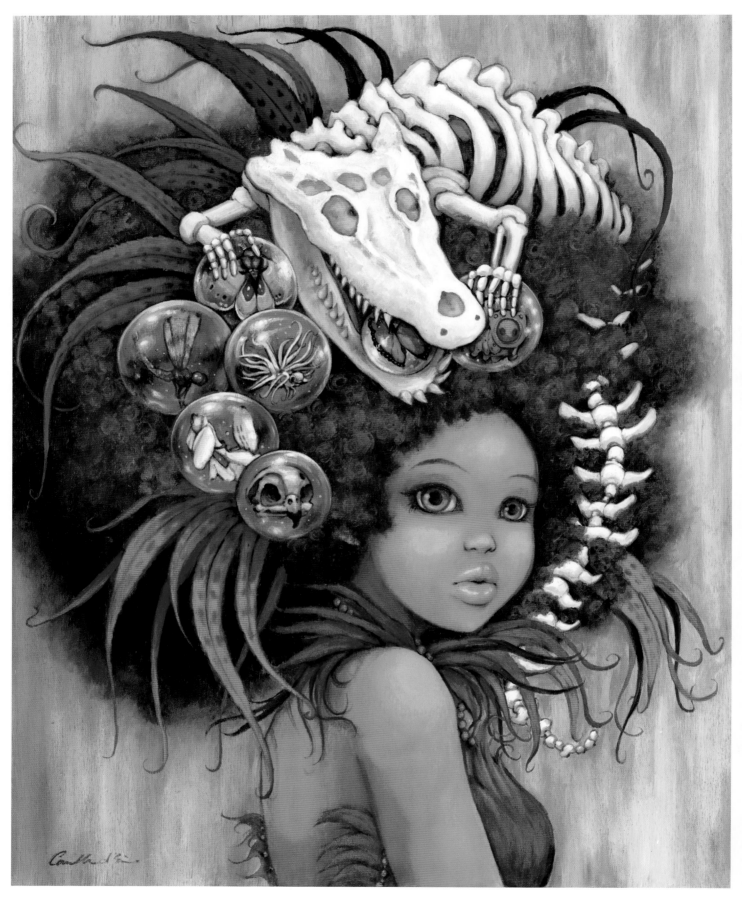

SKY PIRATES OF NEO TERRA PAINTING COMMISSION | MARSHLAND PRIESTESS | 16" x 20" | OIL | 2012

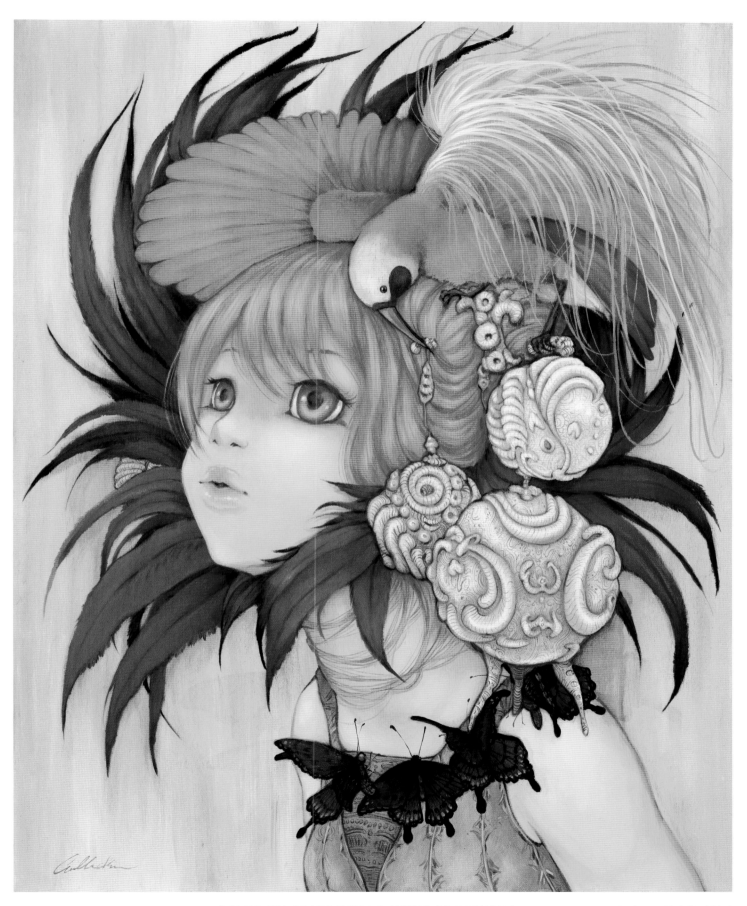

SKY PIRATES OF NEO TERRA PAINTING COMMISSION | *PEAKS OF PARADISE* | 16" x 20" | OIL | 2012

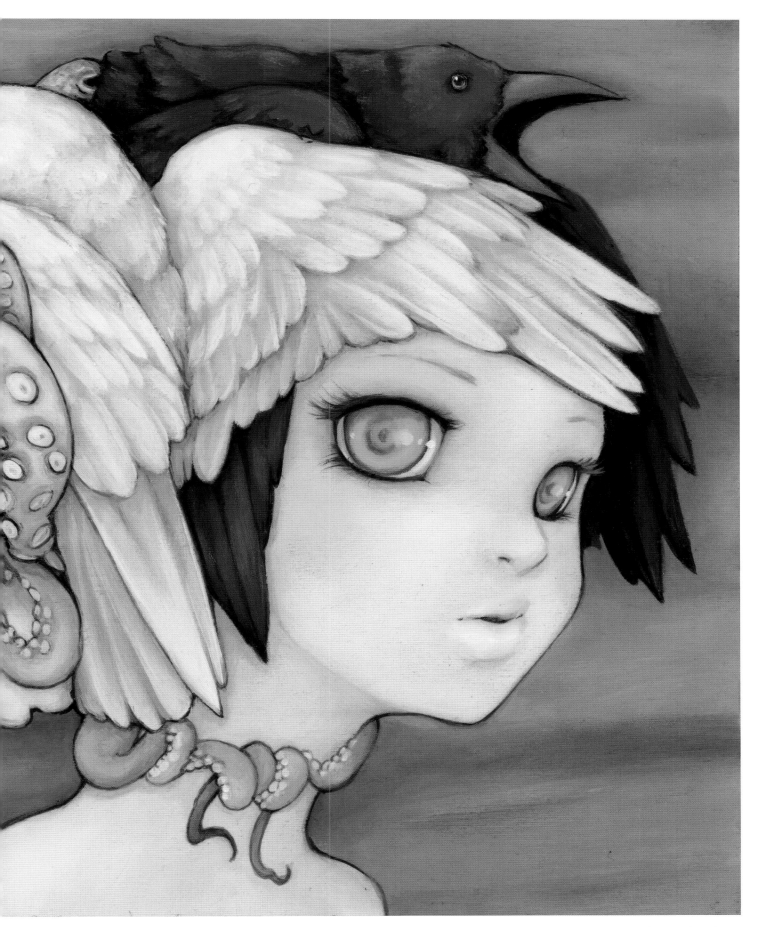

SKY PIRATES OF NEO TERRA PAINTING COMMISSION | *FROM SEA TO SKY* | 10" x 8" | OIL | 2014

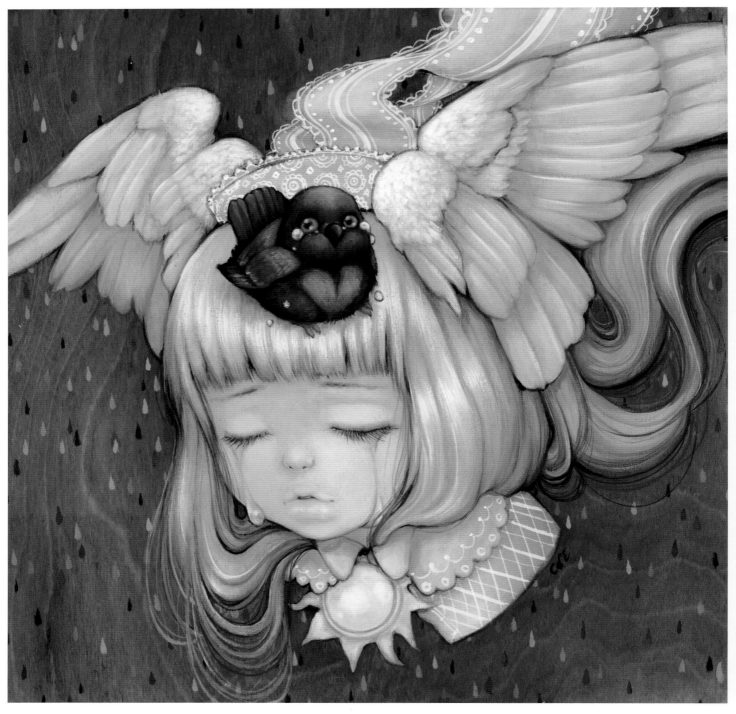

LYRIC 3 | LITTLE BIRD | 12" X 12" | OIL | 2015

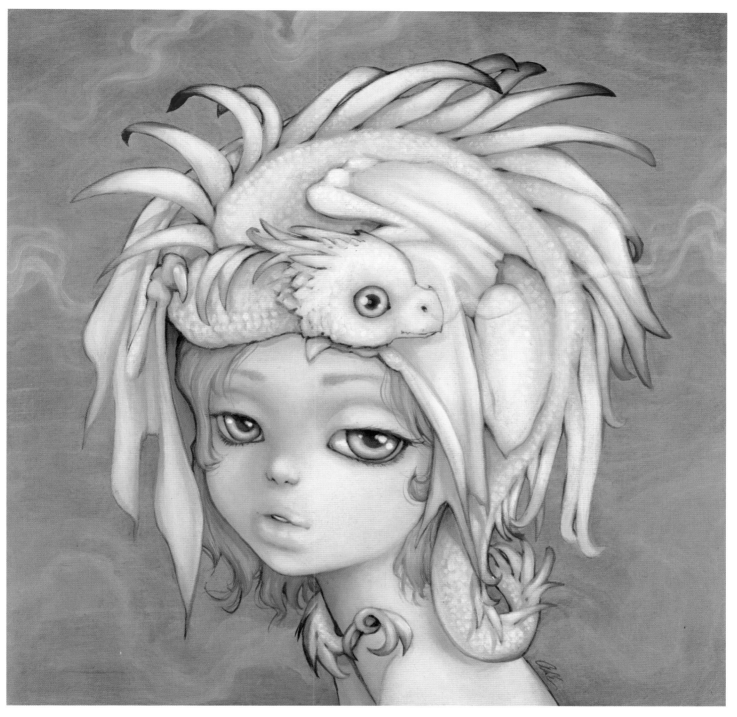

ART COLLECTOR STARTER KIT 3 | PUFF | 12" X 12" | OIL | 2015

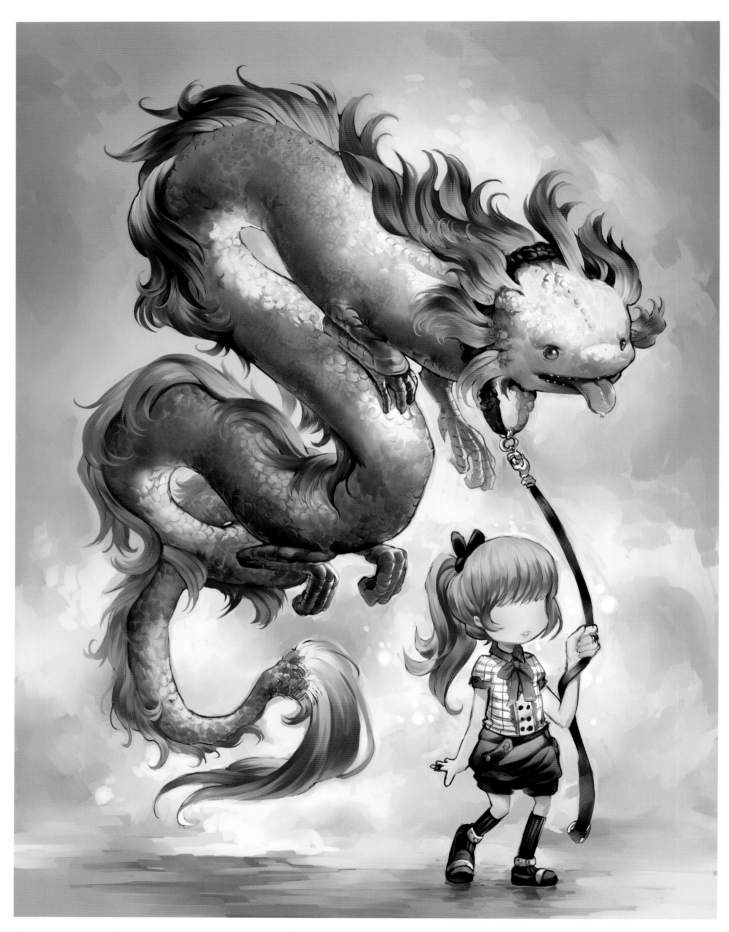

COLORS BY ASUKA111 | SALAMANDER | 11" X 14" | DIGITAL | 2015

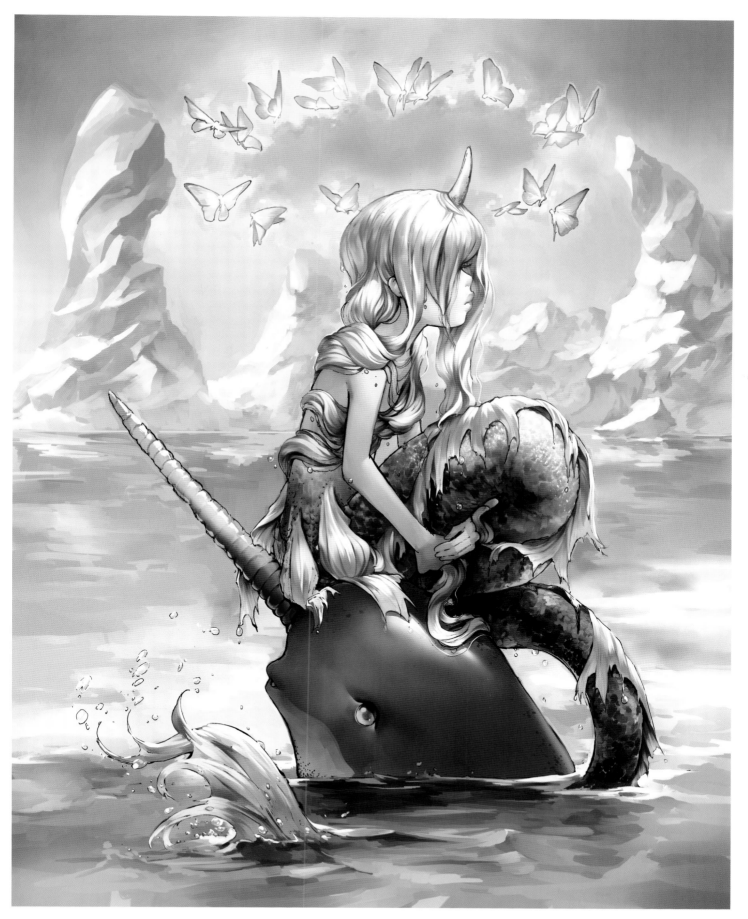

ATLANTIC CITY BOARDWALK CON EXCLUSIVE | COLORS BY ASUKA111 | MERMAID & NARWHAL | 11" X 14" | DIGITAL | 2015

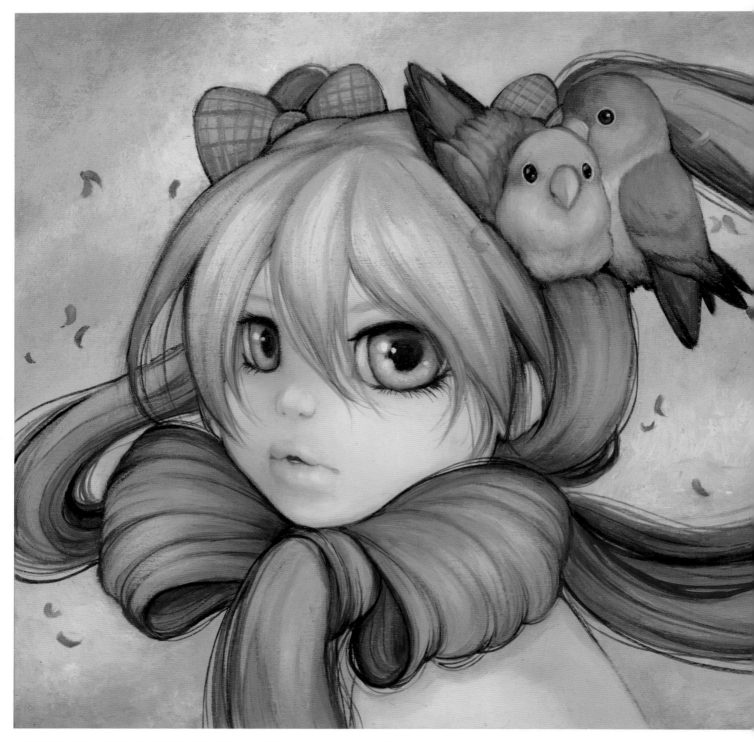

HATSUNE MIKU DREAMS OF ELECTRIC SHEEP | CHIDORI | 10" x 8" | OIL | 2015

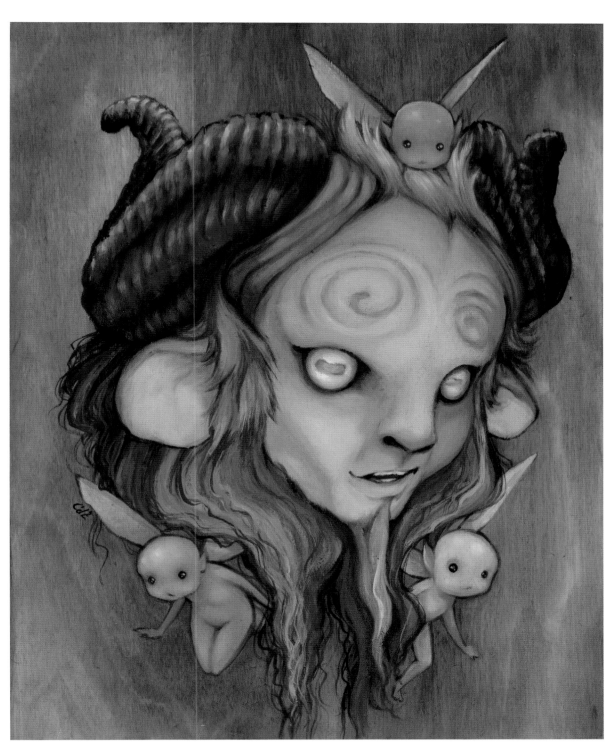

GUILLERMO DEL TORO: IN SERVICE OF MONSTERS | LA CAPRA | 8" X 10" | OIL | 2015

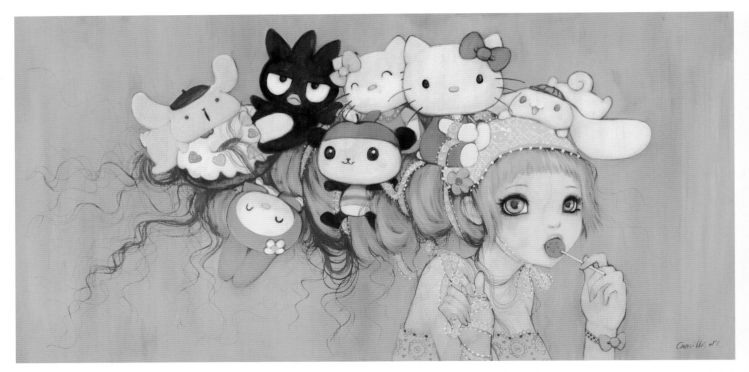

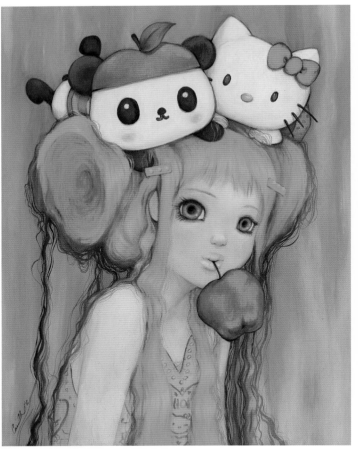

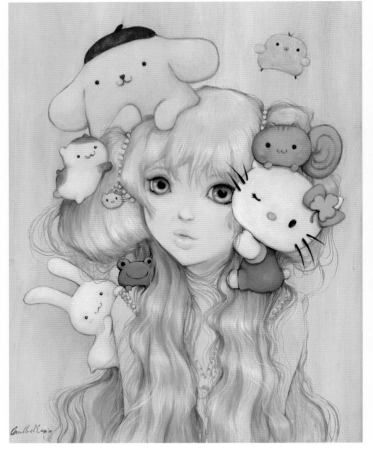

SANRIO | HELLO MY KITTYLAND | 20" x 10" | OIL | 2010
SANRIO | APPLESAUCE | 16" x 20" | OIL | 2009
SANRIO | POM POM KITTY PIE | 16" x 20" | OIL | 2009

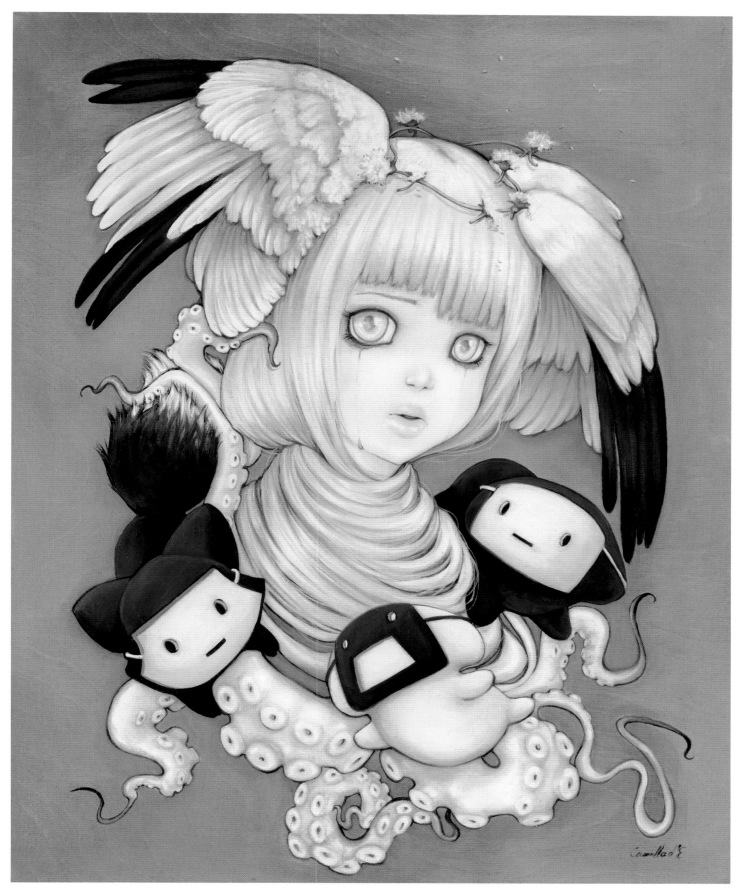

CAMILLA d'ERRICO'S TANPOPO EXHIBITION | DANDELION CROWN | 16" x 20" | OIL | 2012

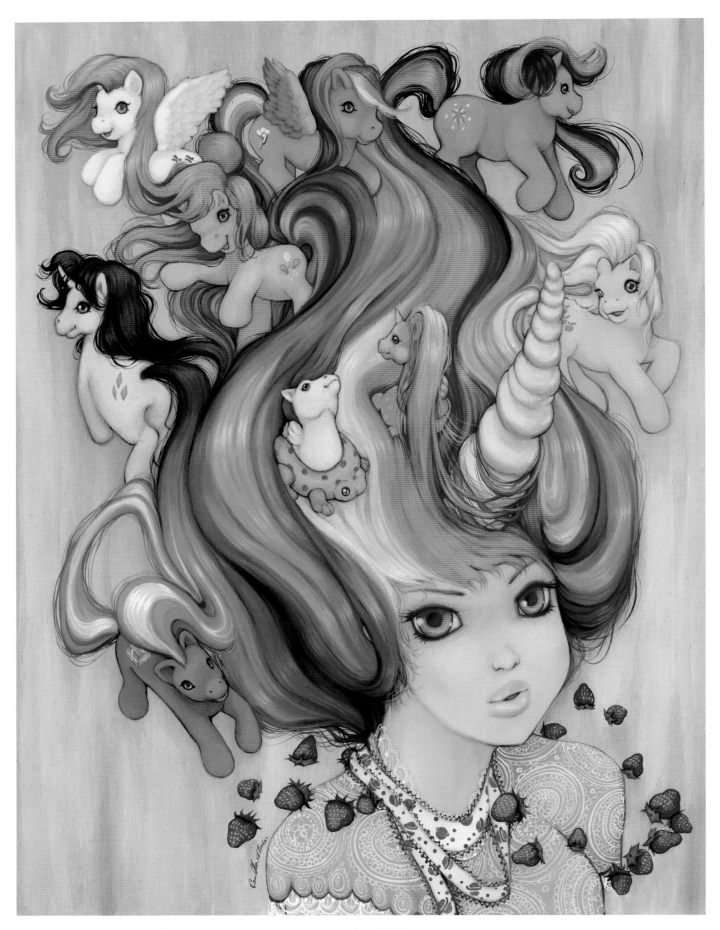

MY LITTLE PONY PROJECT | **MY LITTLE MOONBERRY** | 18" x 24" | OIL | 2012

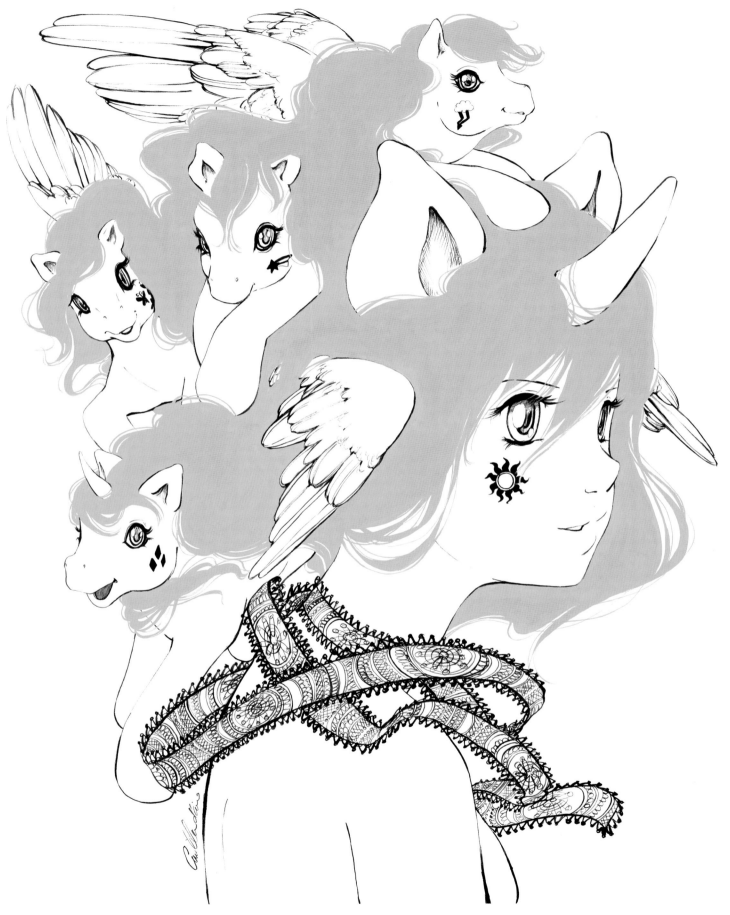

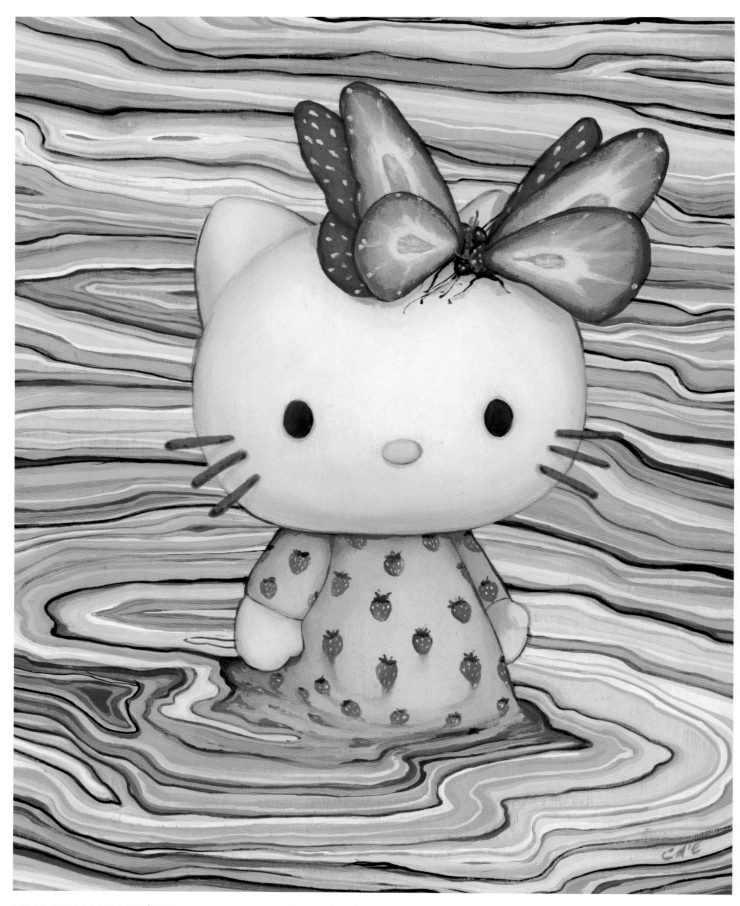

HELLO KITTY CON 2014 | KITTY BERRY KISS KISS | 8" x 10" | OIL | 2014

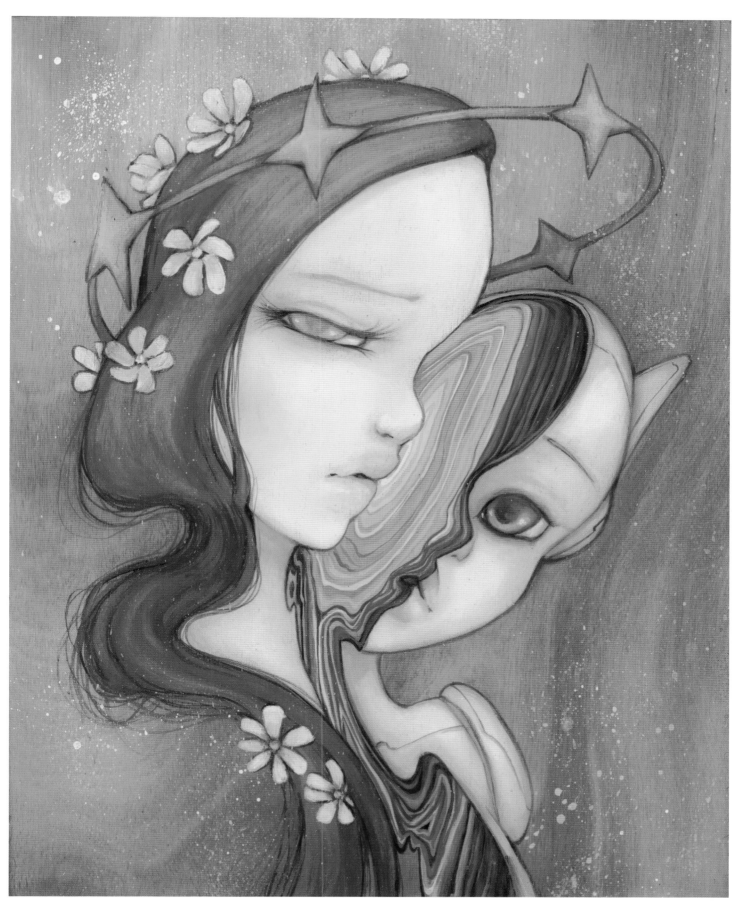

BARBARA CANEPA'S METAMORPHOSE ("SKYDOLL") | TANGLED SOULS | 8" x 10" | OIL | 2014

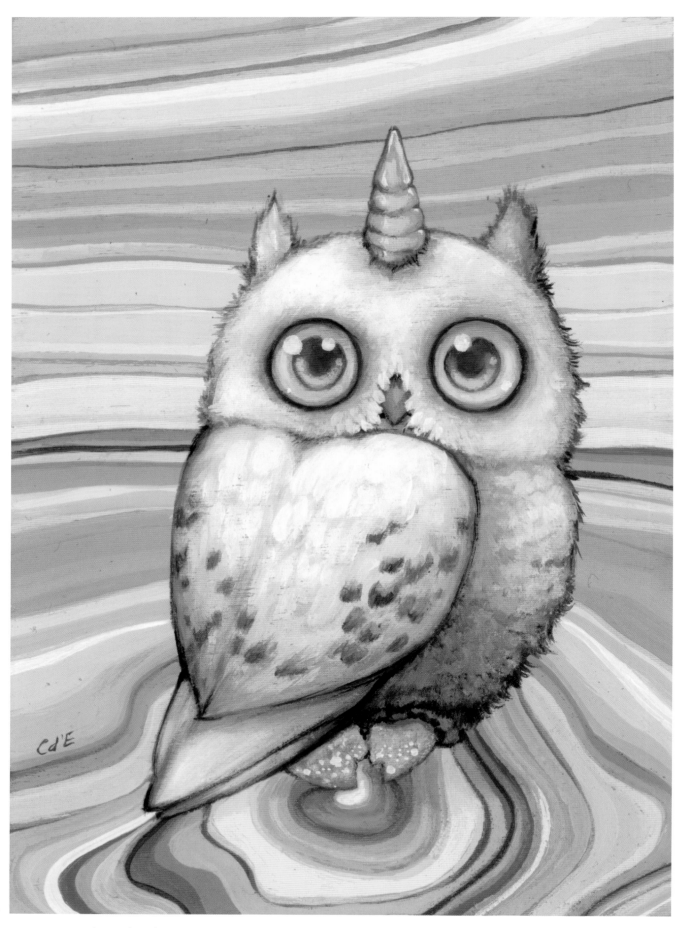

THE HOOTEST | 5" x 7" | OIL | 2015

"I believe that art should be fun, and nothing is quite as enjoyable as a wall-eyed Frenchie with a unihorn!"

BEAUTIES & BEASTIES

BEAUTIES & BEASTIES WAS THE SECOND ANNUAL SHOWING OF TINY PAINTINGS that I offered directly to the public during San Diego Comic-Con International. The first series was based on summer treats, but this series is inspired by one of my all-time favorite creatures . . . unicorns!

I believe that everything is just a little more magical with a horn on it. If a narwhal can rock a giant horn, why couldn't a pug or a little girl?

Beauties & Beasties has an assortment of themes: from cute unihorns and antlers to vivid rainbows, it is my way of expressing my joie de vivre! I even painted a boy! Now that was a fun departure from my usual female-heavy themes. I wanted this series to be cute and fun and just a little funky and strange. I believe that art should be fun, and nothing is quite as enjoyable as a wall-eyed Frenchie with a unihorn!

I will leave it to you to determine who are the beauties and who are the beasties.

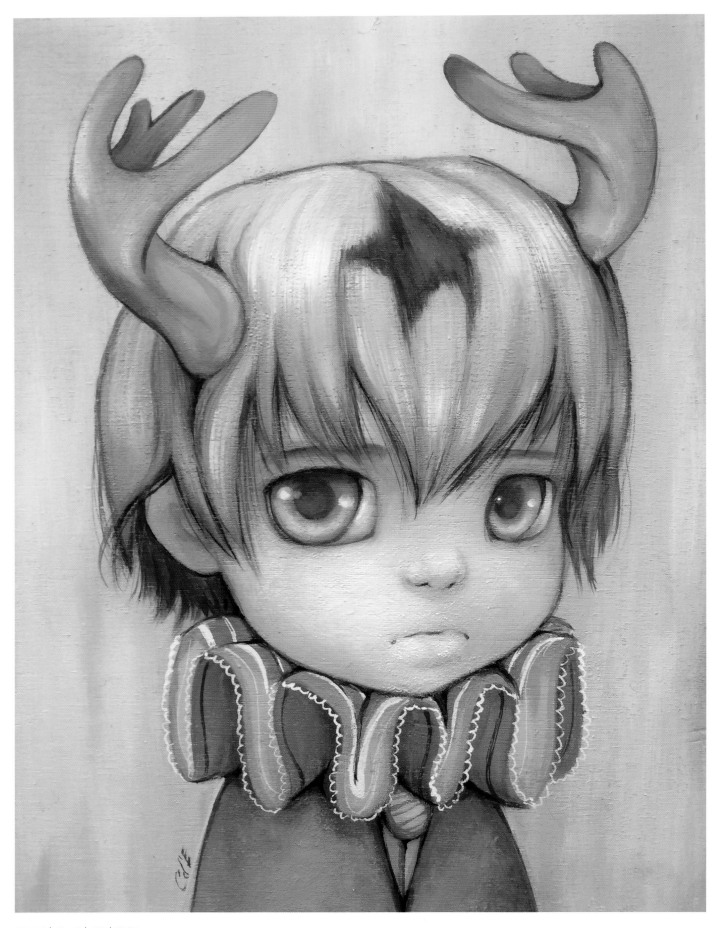

PUCK | 6" x 8" | OIL | 2015

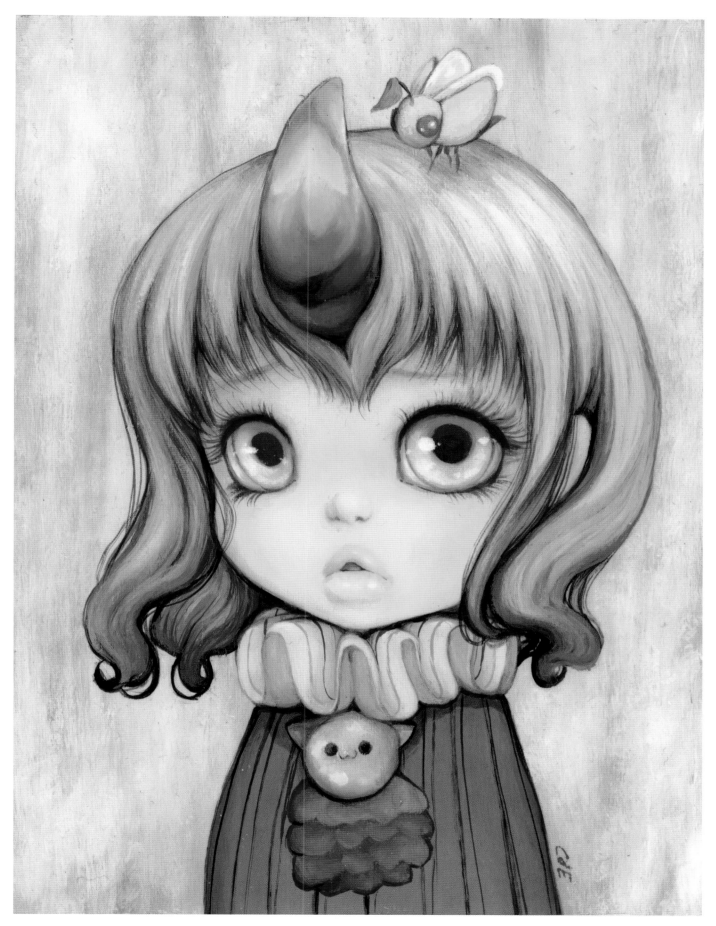

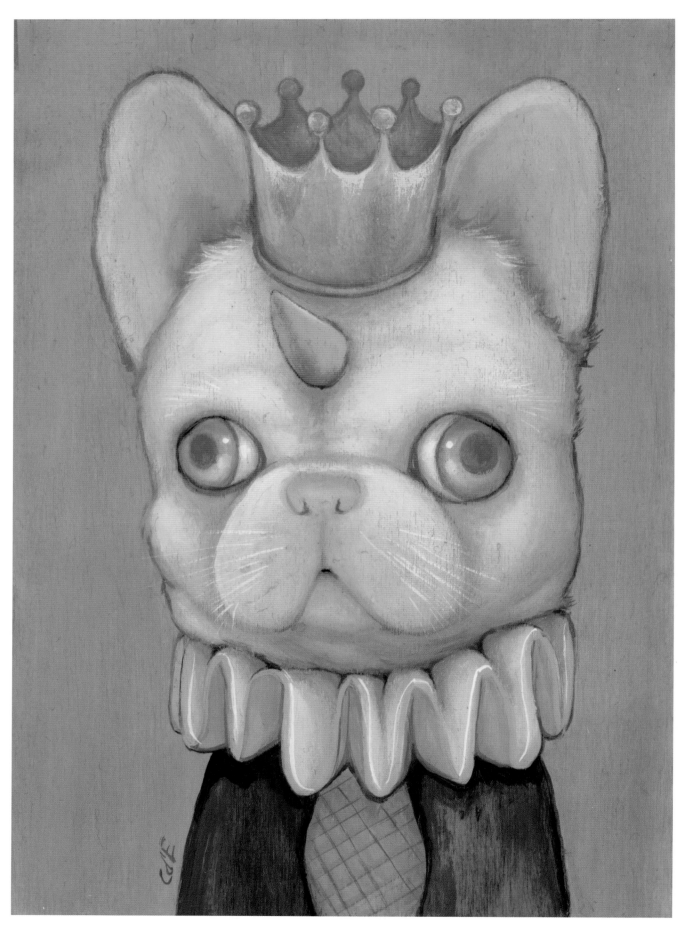

RICHARD THE 29TH | 5" x 7" | OIL | 2015

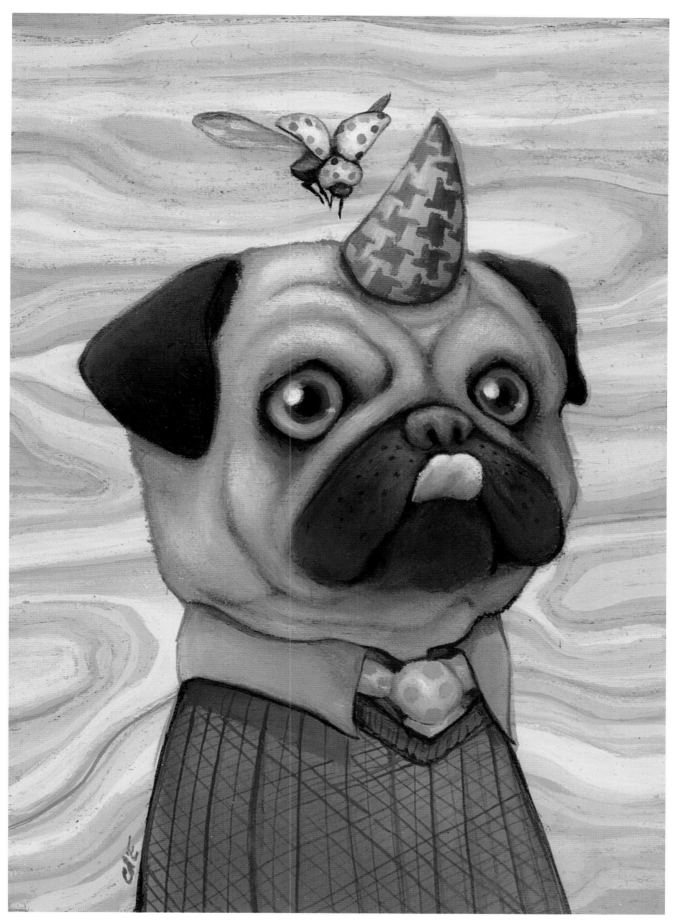

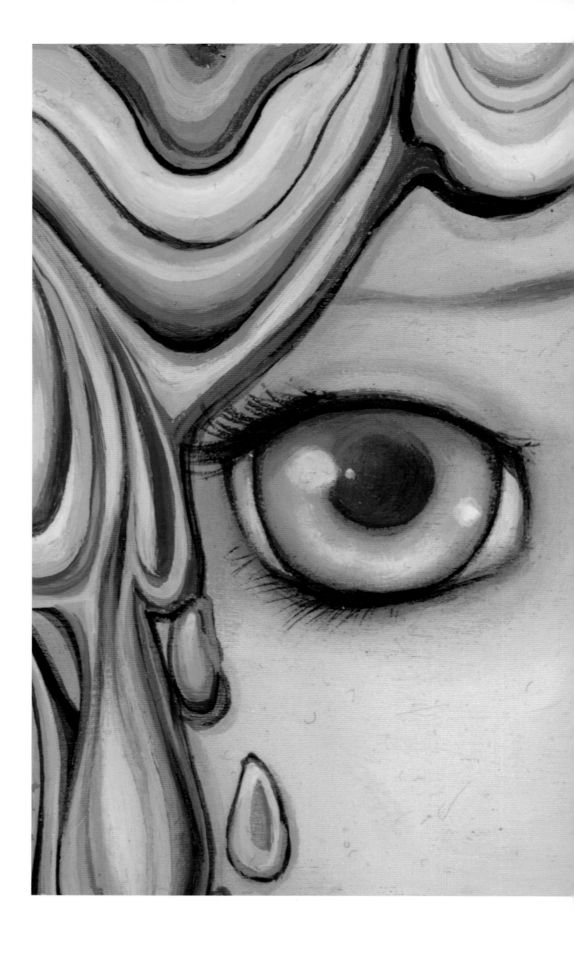

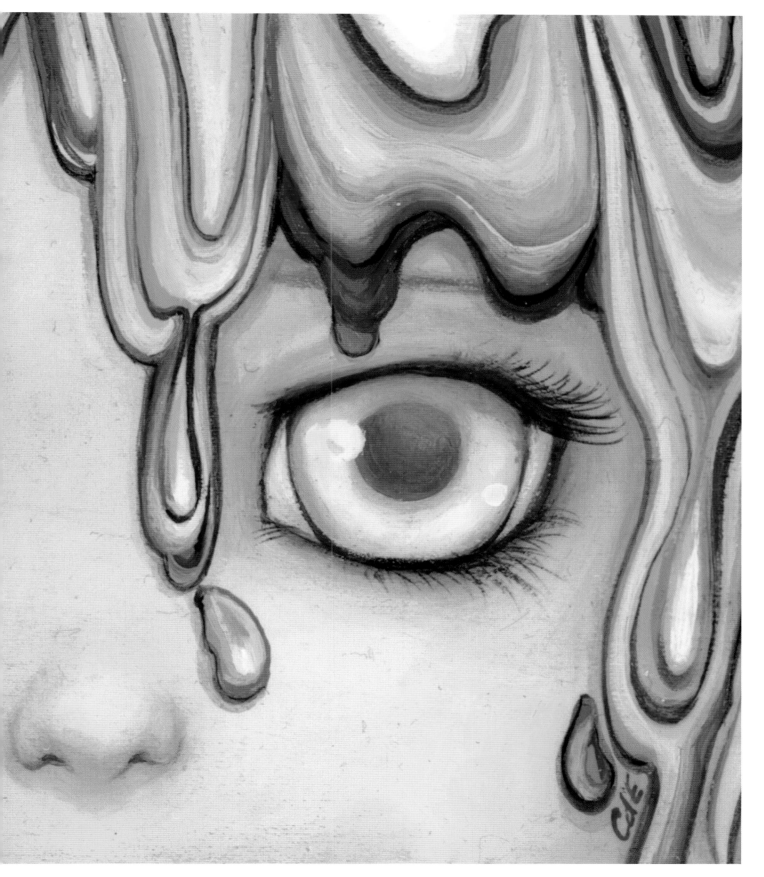

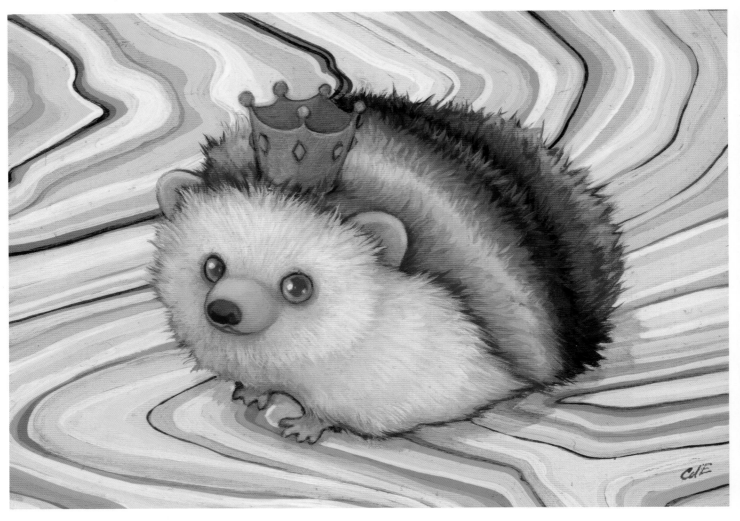

SIR REGINALD WELLINGTON THE 3RD ESQ. | 7" x 5" | OIL | 2015

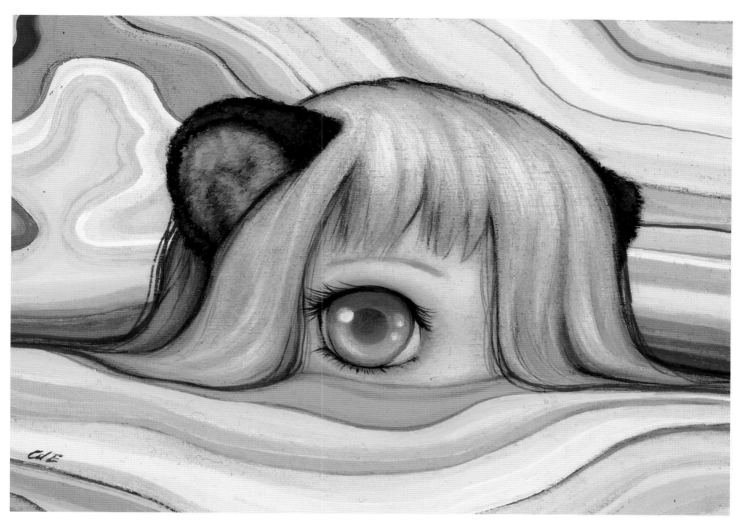

FUZZY WUZZY | 7" x 5" | OIL | 2015

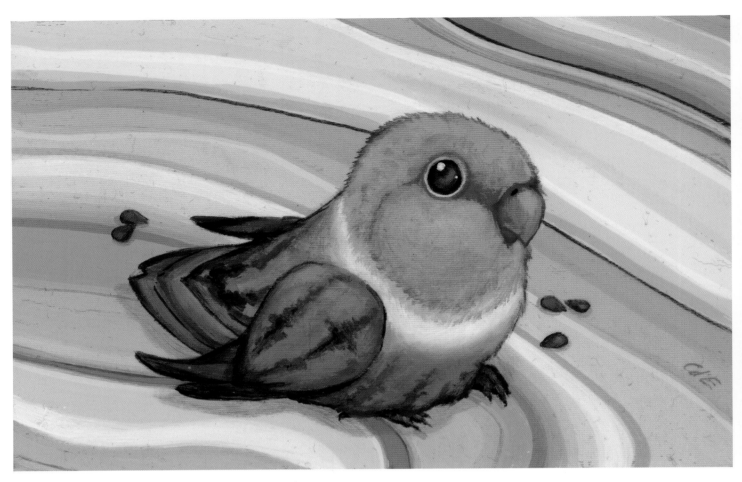

LOVEMELON | 6" x 4" | OIL | 2015

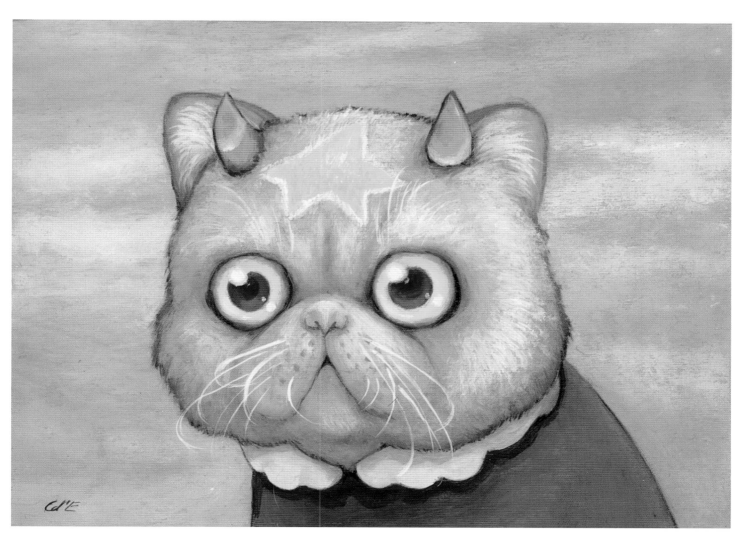

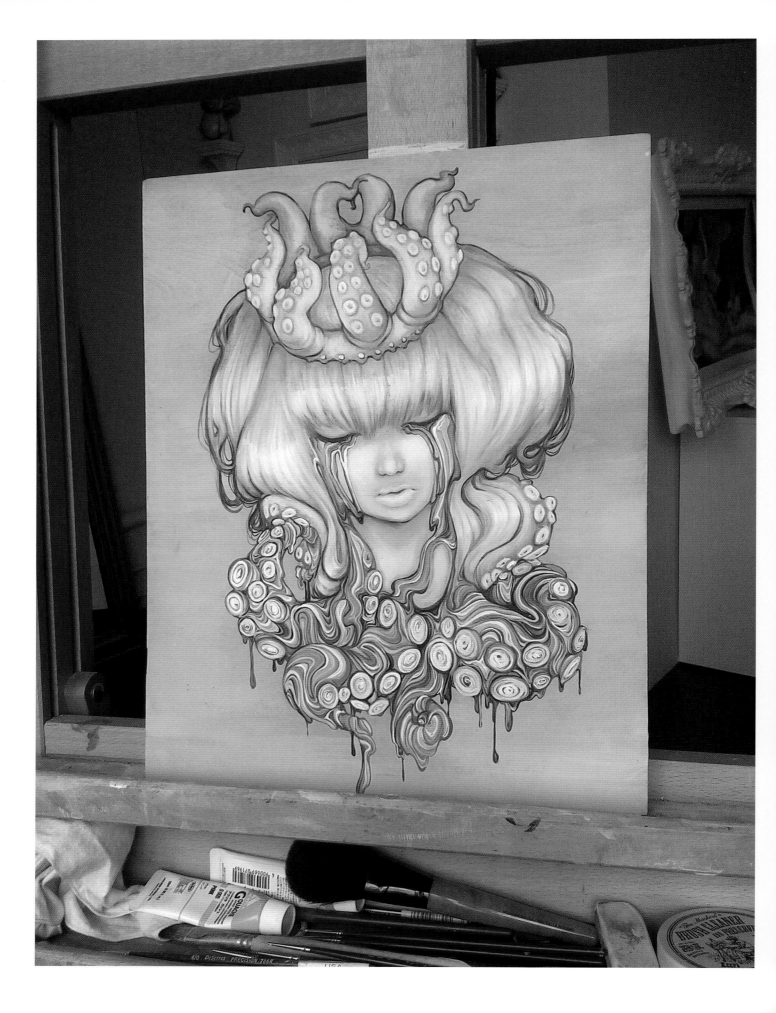

"Art is subjective, and I want the
meaning of the painting to be a personal
experience for the viewer."

PAINTING PROCESS

I THINK IT IS ALWAYS COOL TO SEE BEHIND-THE-SCENES PHOTOS and snapshots of artists at work, so I thought it would be fun to include some of my painting process of *Dream Melt* for this chapter.

Many people ask me what I use to create my art; it's one of the top questions that I'm asked. I use Holbein Duo oils to paint with, and I work on lightly sanded birch plywood panels. I first discovered these paints while I was working at Opus Art Supplies in North Vancouver shortly after I graduated from the IDEA program at Capilano University. I have to say that these are the most amazing paints I have ever worked with. They are oils that you can blend with water. I know, I know—oil shouldn't blend with water, but these paints do. They are amazing and versatile to work with because you can create washes of color and at the same time build up your layers like you can with standard oil paints.

There are many layers involved when I create my work, and *Dream Melt* was no exception. This was a particularly interesting piece because as I was painting, the girl's personality seemed to evolve and create itself through me. I envisioned her as a happy character; then something changed halfway and I began to see another side of her emerge. When I began to paint her rainbow tears, I knew that this would be one of the most distinct pieces in the series.

Often people ask me about the meaning of this painting, but I don't ever tell them. Art is subjective, and I want the meaning of the painting to be a personal experience for the viewer. If I tell you what I think of this image, then it would take away from what you see, so I will keep what I think of her a secret and allow you to see *Dream Melt* for what it is to you. That is the true meaning of this painting.

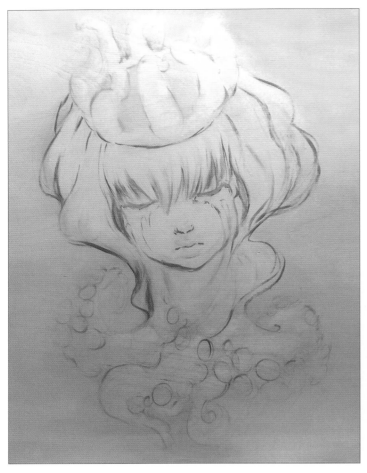
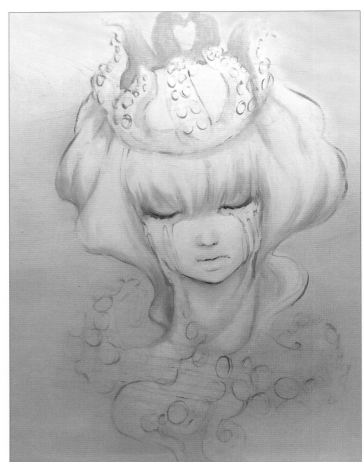
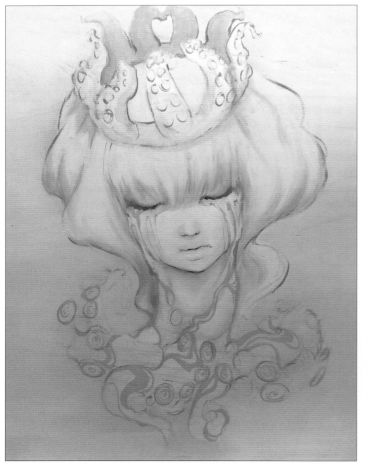
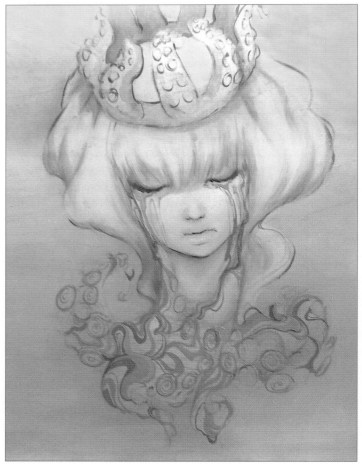

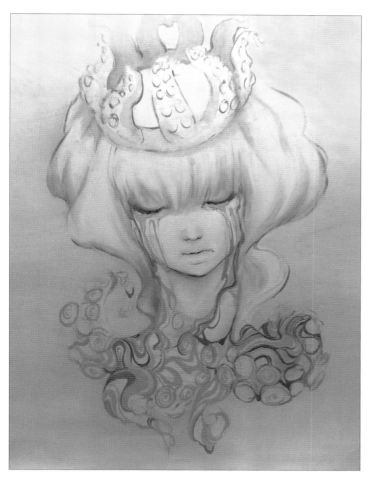
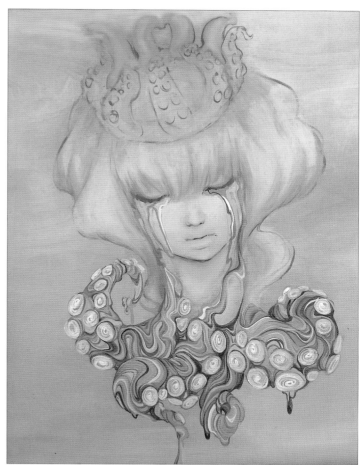
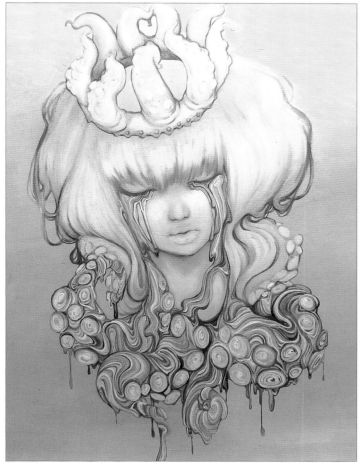
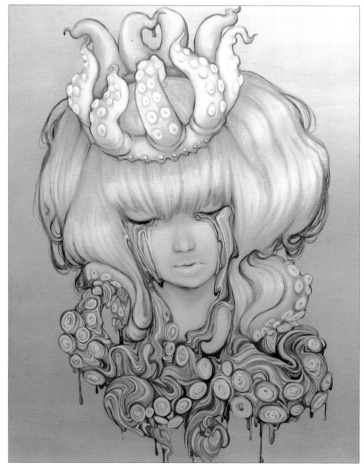

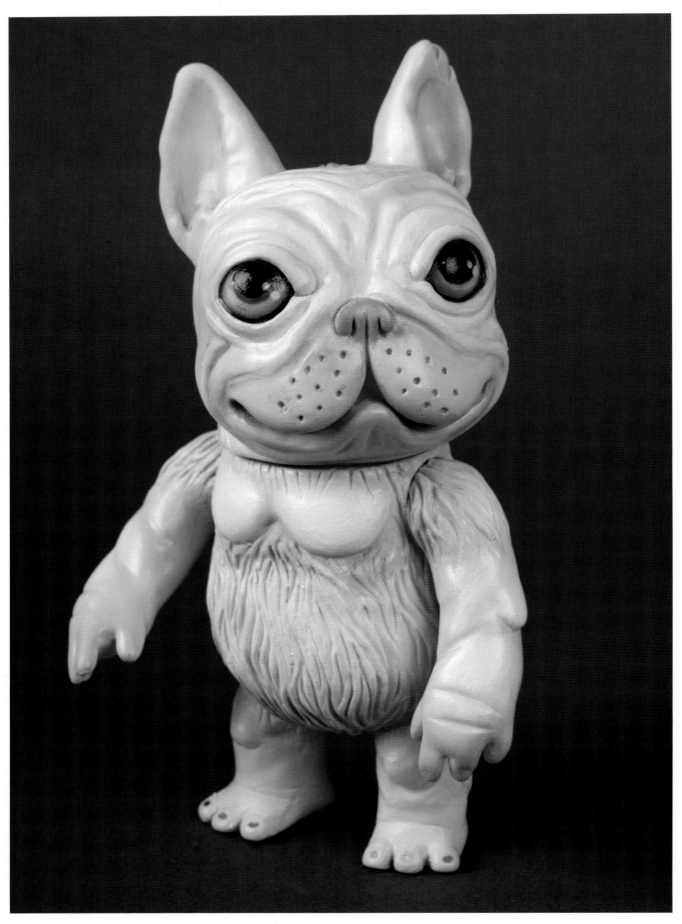

SLEEPWALKER NIMBUS EXHIBITION | TIE DYE | ACRYLIC | 2015

3-D PAINTINGS

HAVE YOU EVER WANTED TO PAINT ON A TOY? Or maybe you've been dying to take that beautiful piece of wood you've got lying around and turn it into a colorful portrait. If you are like me, then you've definitely had those thoughts, and you've acted on them!

One thing that is super unique in the pop surrealist movement is its parallel with the vinyl toy industry and its *customizable* vinyl toys.

They come in all shapes and sizes: whether dinosaurs, robots, or French bulldogs, there seems to be no end to their varied forms. It's a blast to see a colorful image emerge from a blank toy. I use acrylic paints when I work on vinyl and switch back to Holbein Duo oils when I am working on wood. I find it much easier to work with a faster-drying paint when working in 3-D rather than the slower-drying oil paints. It's a bit hard to pick up your canvas and turn it upside down and around when the paint is still wet.

This chapter is all about the custom 3-D objects I've painted in the past few years. I hope you enjoy the variety of melty rainbow girls I've created on strange and bizarre shapes.

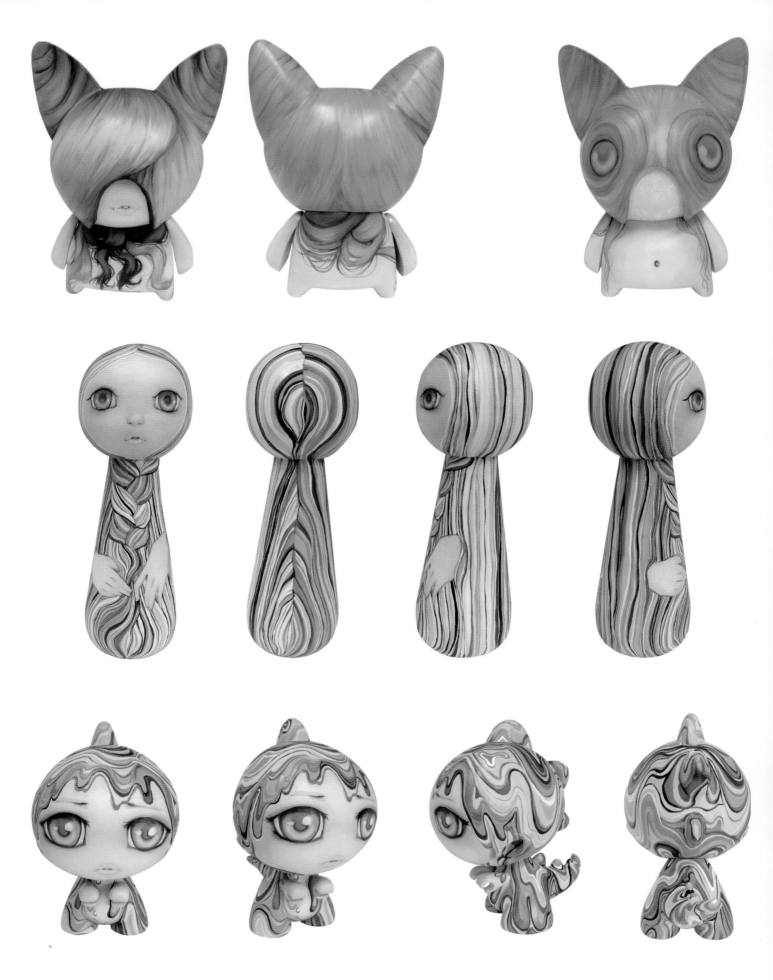

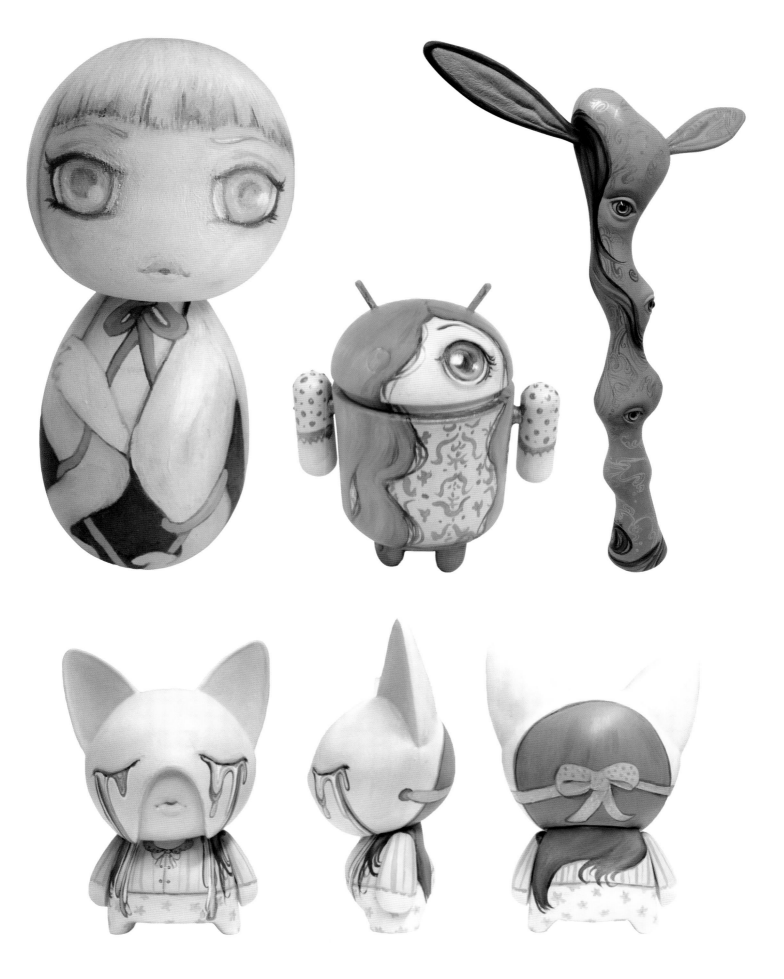

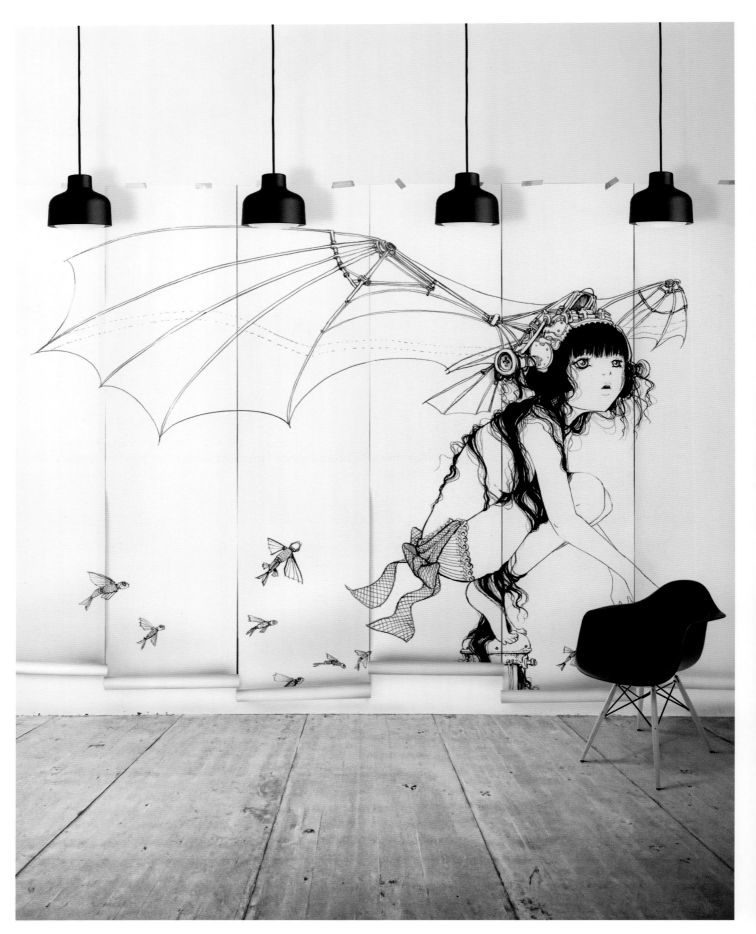

MERCHANDISE

ONE OF THE THINGS I ABSOLUTELY LOVE IS ART-WORK THAT YOU CAN WEAR OR USE! I don't know who coined the phrase "wearable art," but I made that my business mantra. I've had my images on a variety of products, including pillboxes, furniture, ponchos, and pillows, just to name a few. I love the way great designers can fashion their products into exclusive limited editions using 2-D imagery. It brings the artwork to life in a whole new way that is fresh and exciting.

Over the years I've worked with companies like Nuvango, Limited Edition, Poprageous, Gold Bubble, Eyes on Walls, Wallpaper Republic, Killer Tentacle Octopus, Clearly Contacts, Mighty Wallet, WeLoveFine, Rubbish Rehab, Haut Totes, and Hot Topic to create a variety of products with my artwork on them. The photos in this chapter are just a taste of what I've created over the years, and in the years to come I'm sure to create even more . . . I just can't help myself.

I've been asked before what my dream product would be, and I think I would love to one day have a full clothing line with custom creations based on my paintings. It's one of my greatest ambitions to have a runway show of my designs. So all I can do is keep creating and taking those baby steps to reach my ultimate goal.

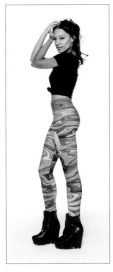
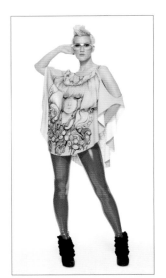
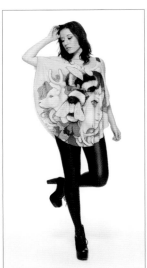
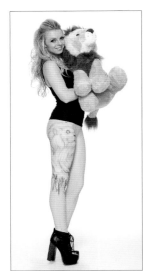

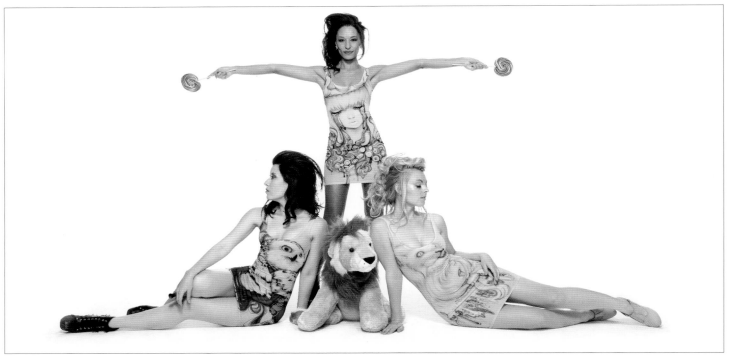

GOLD BUBBLE CLOTHING

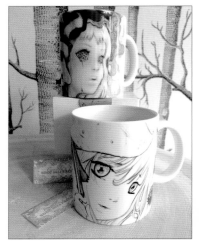
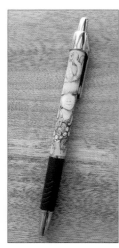
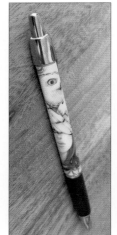
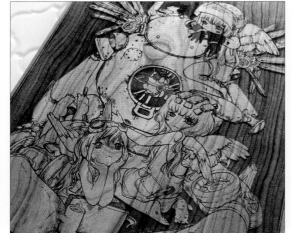

D'ERRICO STUDIOS LTD. D'ERRICO STUDIOS LTD. SPITFIRE LABS

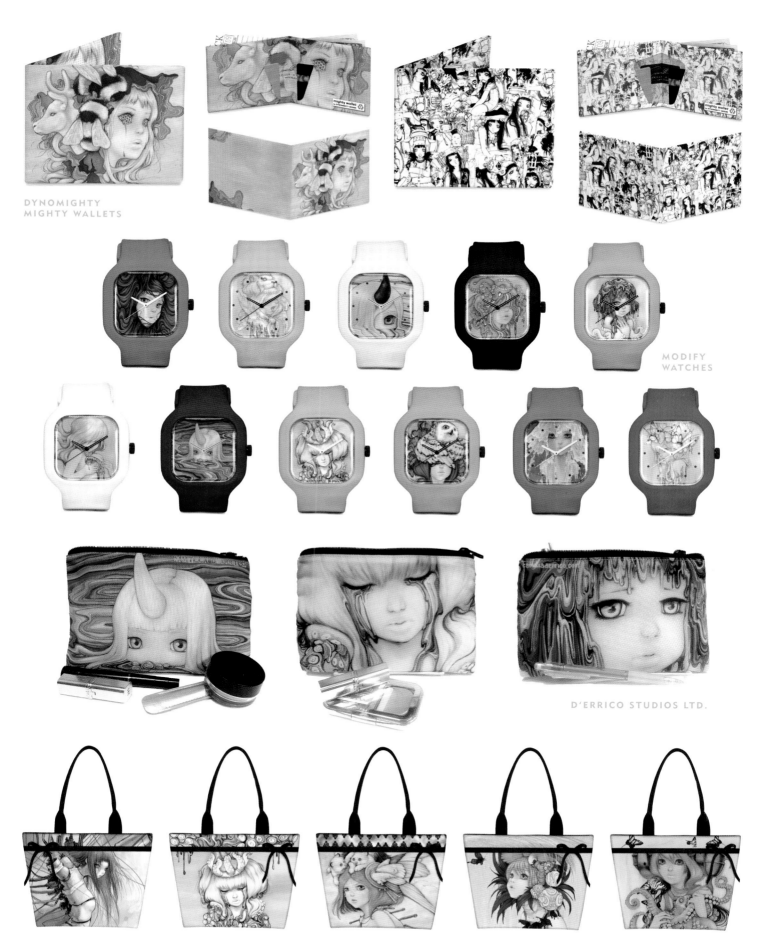

DYNOMIGHTY
MIGHTY WALLETS

MODIFY
WATCHES

D'ERRICO STUDIOS LTD.

HAUT TOTES

143

 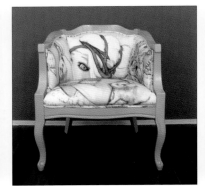 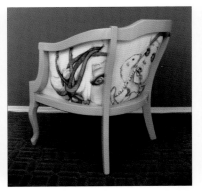

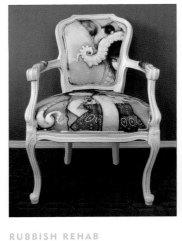 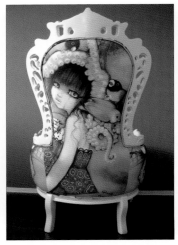 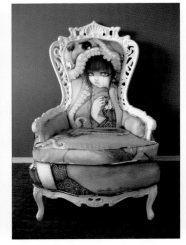 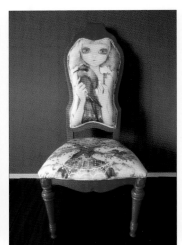

RUBBISH REHAB

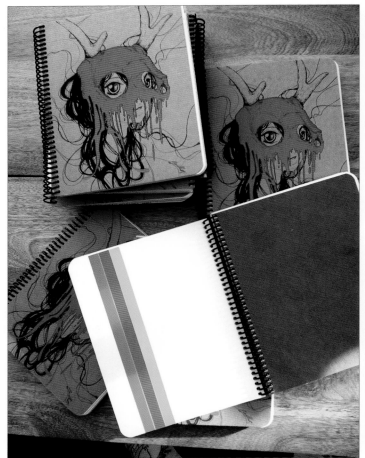 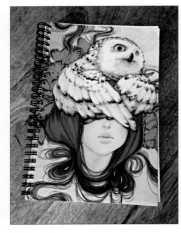 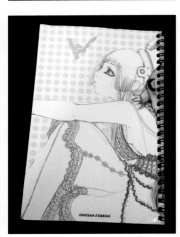

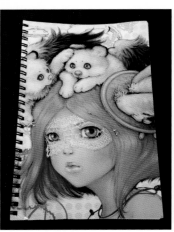 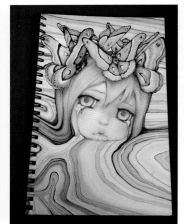

RESKETCH BOOKS

144

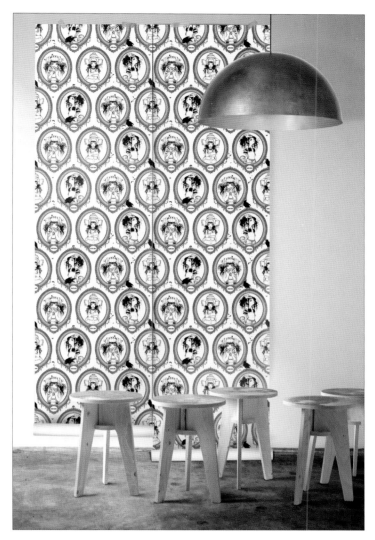
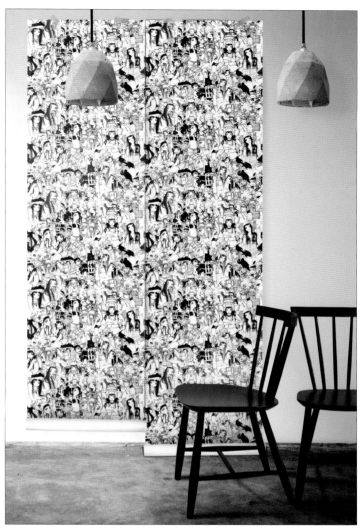
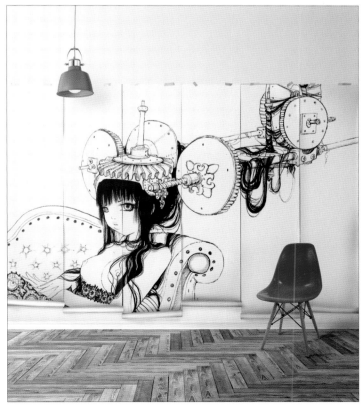
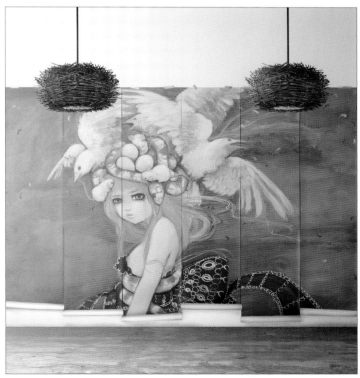

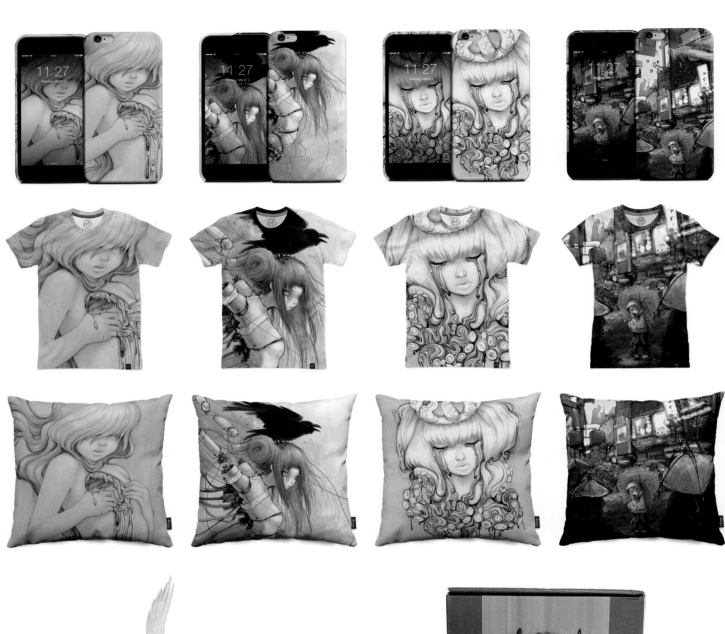

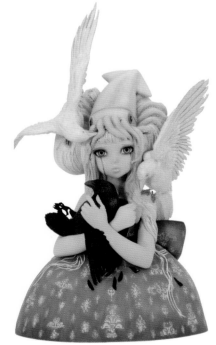

DARK HORSE COMICS NO ORDINARY LOVE STATUE

TOOLS OF THE TRADE GLOBAL

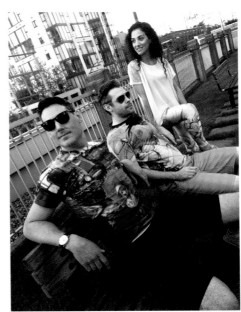
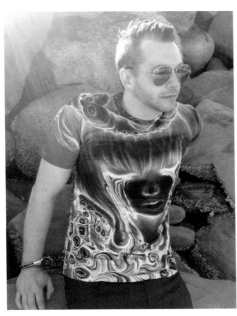
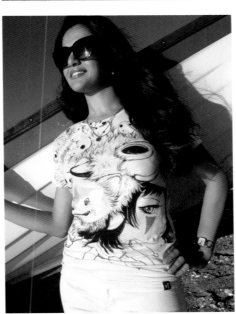

NUVANGO

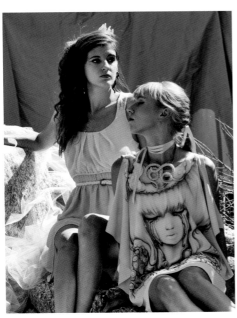
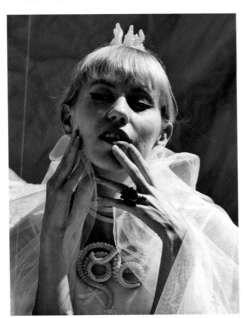
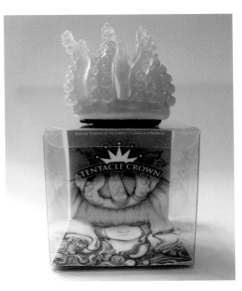

KILLER TENTACLE
OCTOPUS TENTACLE CROWNS

147

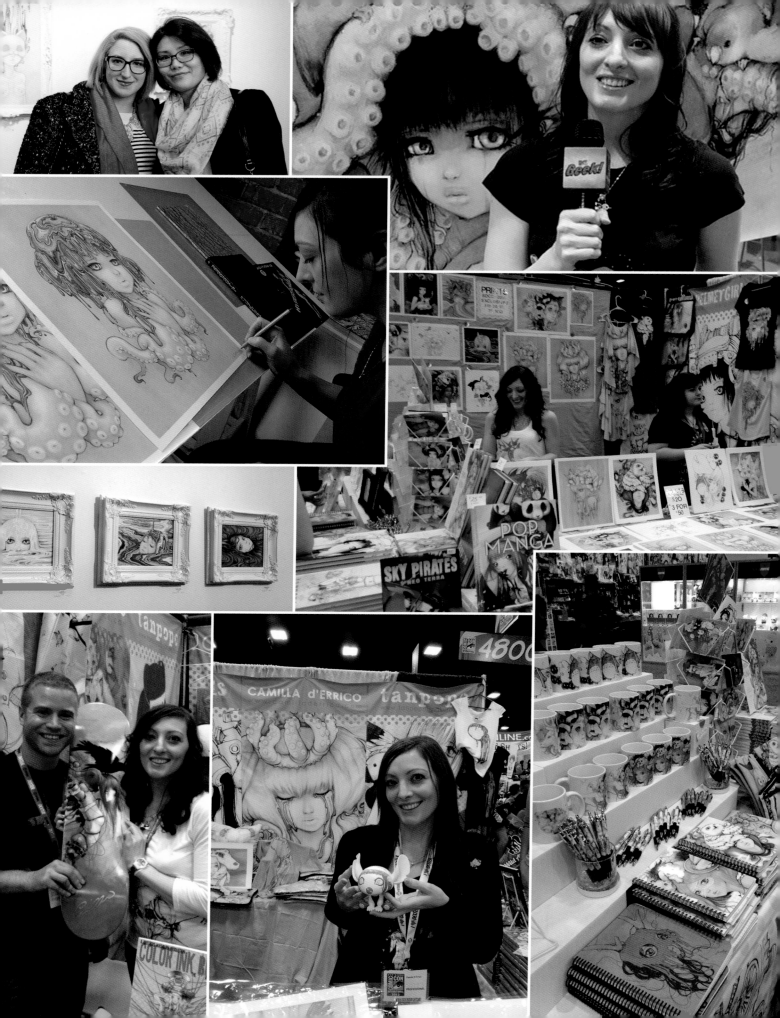

EVENTS

This is the behind-the-scenes story of a very happy girl who gets to share her drawing with everyone.

I'm a very social artist, and I love going to conventions and trade shows to set up my booth, say hi to old fans and meet some new ones, and share my artwork with the public. I create graphic novels for well-known publishers in North America and cover art for other comic books, so I travel to thirteen or more comic book conventions every year. It's hard to juggle traveling and work, but I do it so I can meet the people that have supported my career and talk to them face to face.

It's such an honor to meet the people who support me. Even when I spend thirteen hours on a plane with a choir of screaming babies onboard, I show up at a convention happy as a clam and ready to say hi to the public.

I create artwork for galleries all over the world, so I get to travel to attend opening nights and socialize. I'll end up spending most of my night talking and mingling. This is an entirely different experience than a convention or a book signing; here I am able to focus on certain pieces and explain my process directly. Seeing original art in person is always a unique experience.

I don't really know the impact a painting or drawing will have until I meet people in person. I've been blown away by some of the stories I've heard and the interpretations of my artwork.

It is true that art is subjective and has multiple meanings, but what isn't subjective is someone's experience with the creator of that artwork. I want every experience that I have with someone who likes my work to be a positive one. I am so thankful each and every day for what I get to do, and I owe it all to the people who support me. I will never, ever take that for granted.

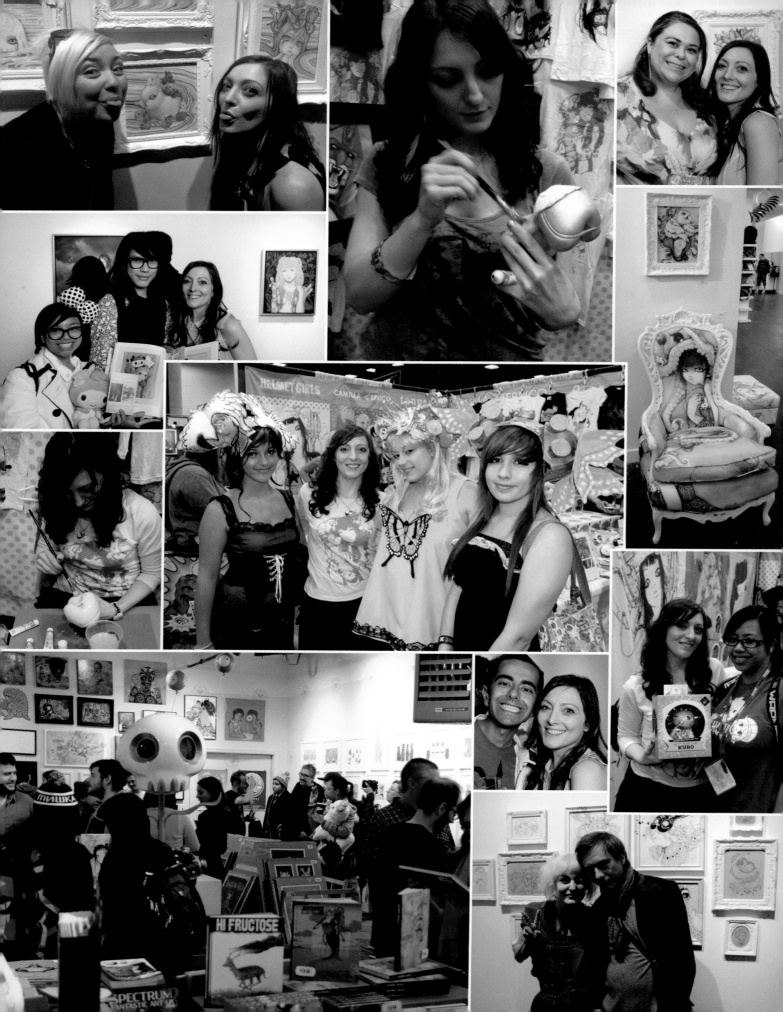

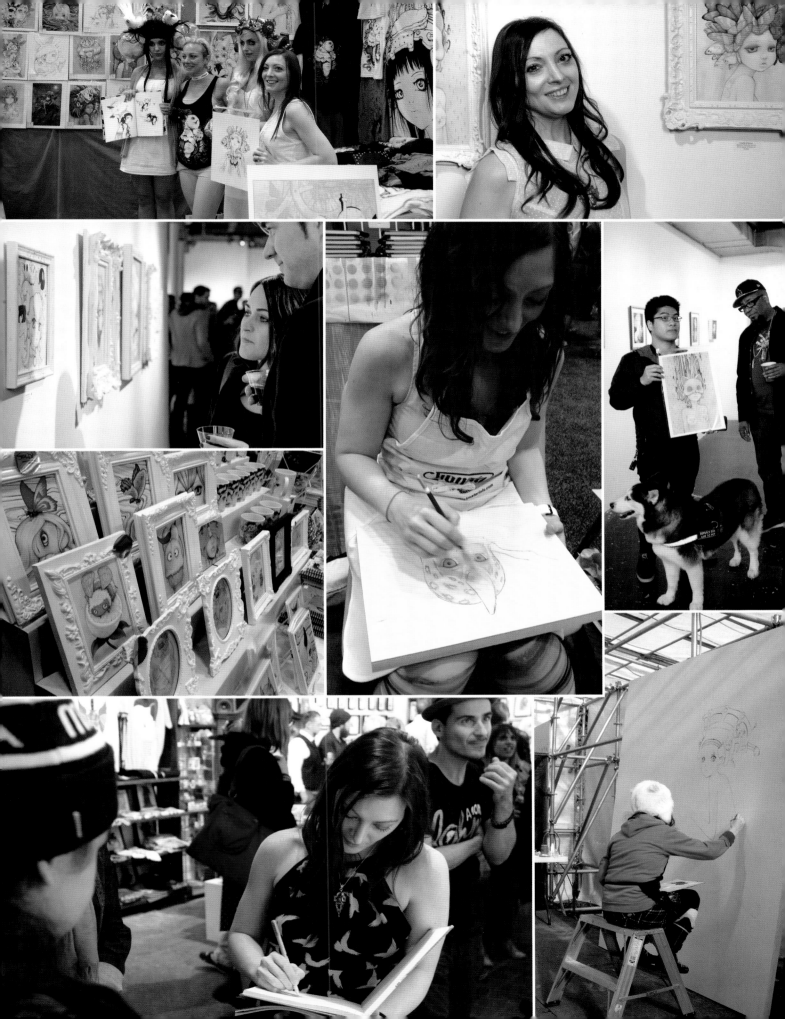

 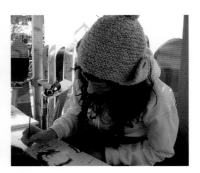

AUTHOR'S PAGE

CAMILLA D'ERRICO IS A PAINTER, ILLUSTRATOR, CHARACTER CREATOR, AND COMIC ARTIST RESIDING IN VANCOUVER, BC. Camilla's beautiful work is seen in galleries all over the world, in books, and on toys, clothes, accessories, and more. Camilla has been making waves in the fine art and comic industries with her manga-influenced style since 2000. Ever prolific, she has worked with renowned companies such as Disney and Hasbro, she has been published by Random House (*Pop Manga*, *Pop Painting*), Simon Pulse (*Camilla d'Errico's Burn*), Image Comics (*Sky Pirates of Neo Terra*, *Fractured Fables*), IDW (*Swallow 5*, *Sparrow 13*), and Dark Horse (*Femina & Fauna: The Art of Camilla d'Errico*, *Helmetgirls: The Art of Camilla d'Errico*, *MySpace Dark Horse Presents*). She publishes her own literature-inspired graphic novel series, *Tanpopo*, with Boom! Studios and has created covers for multiple series, including *Adventure Time: Marceline and the Scream Queens*, *Elephantmen*, and *Bee and PuppyCat*. Camilla has distinguished herself as one of the breakthrough artists in the pop surrealism movement through her ability to seamlessly weave manga and Western styles with surrealist elements, wrapping them together with an extensive emotional palette. She has shown her work in galleries such as Thinkspace Gallery and Corey Helford Gallery in Los Angeles, Ayden Gallery in Vancouver, Cotton Candy Machine in New York City, Strychnin Gallery in Berlin, Art Basel in Miami Beach, Gallery Tomura in Tokyo, Mondopop in Rome, and more. She has a unique style that bridges cultural and geographical boundaries while remaining totally relevant to today's varied audience.

She finds joy in angst, in shape and form, color and texture, and all things that embody passion. Camilla captures the tension, the drama, and the unrest in people's faces and emotions. She lives by the motto "It is about expressing what they feel and feeling what they express."

For more information about Camilla, visit CamilladErrico.com or join her fan page at Facebook.com/CamilladErricoArt.